The Student Journalist and Creative Photography

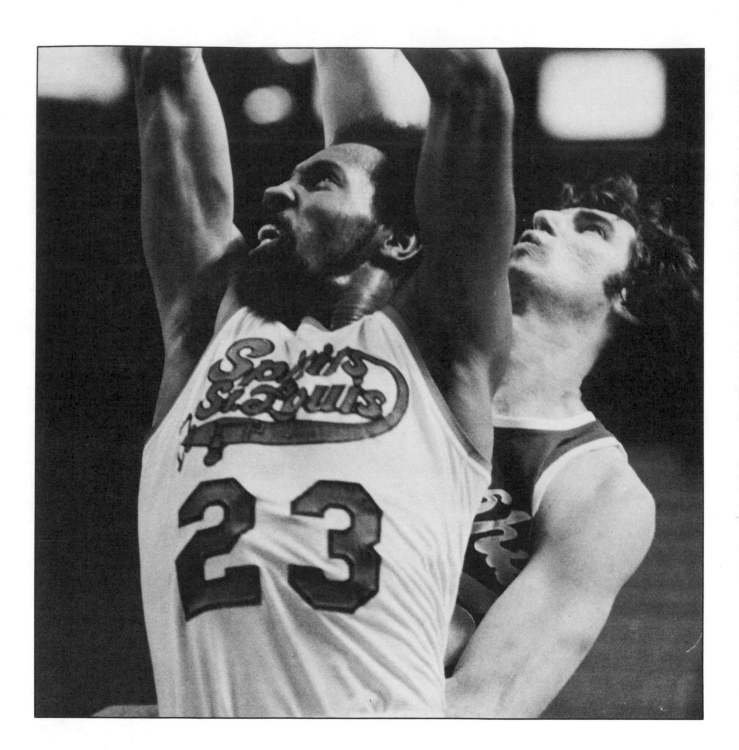

The Student Journalist and Creative Photography

Text and photographs by Bill Ward

Professor of Mass Communications
and Director of Journalism
at Southern Illinois University, Edwardsville

80-23

Published by
Richards Rosen Press

Other books by the author

The Student Journalist and Creative Writing
Editorial Leadership
Writing Editorials
Thinking Editorials
Designing the Opinion Pages
Common Story Assignments
Depth Reporting

Newspapering
The Student Press #1 and #2
Writing in Journalism
My Kingdom for Just One Strackeljahn
The Photographer as Reporter

Published in 1976 by Richards Rosen Press, Inc.
29 East 21st Street, New York, N.Y. 10010

First Edition

Library of Congress Cataloging in Publication Data

Ward, William G
 The student journalist and creative photography.

 (Student journalist guide series)
 SUMMARY: A study of creative photojournalism and its
use in school publications.
 1. Photography, Journalistic. 2. School photography
 [1. Photography, Journalistic. 2. College and school
journalism] I. Title.
TR820.W39 770'.28 75–30781
ISBN 0–8239–0335–4

Manufactured in the United States of America

This book is dedicated to Ruth and Dick whose inspiration and friendship and whose dedication to publishing have guided me through the fascinating world of books.

In this book

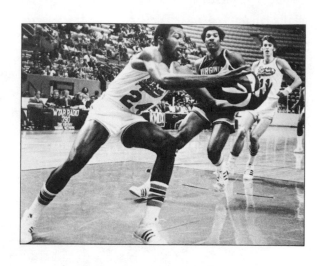

 The photograph of the author in the intro-
 ductory section was taken by Jim Mildon.

About the Author

The author started photographing 20 years ago when as a high school football coach he took a Rollei onto the sidelines with him and became more interested in football imagery than in winning games. He has taught photography in two high schools and two universities. He has published several hundred photographs in books, magazines and newspapers. He has been a photo editor. Over the years he has become more and more firmly a believer in the objectives of photojournalism, in 35 mm. cameras and the use of available light, and in an understanding of photography from both technological and intellectual points of view. He formulated the journalism major program in 1970 at Southern Illinois University. He is director of that innovative program and professor of mass communications.

The Student Journalist and

Creative Photography

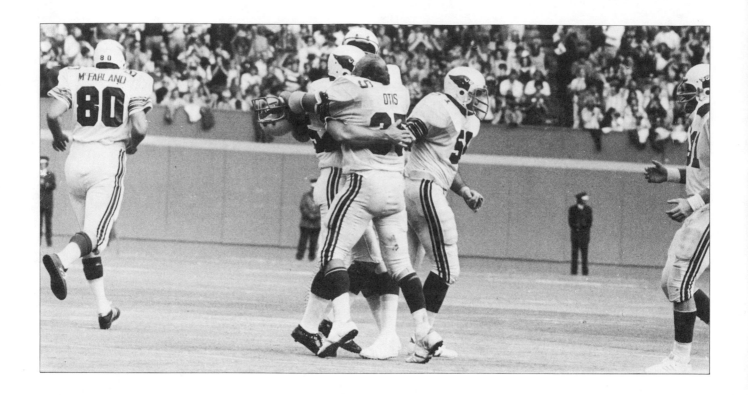

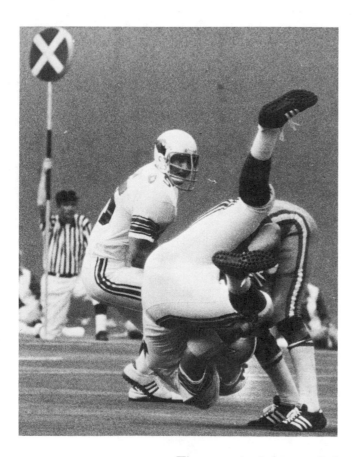

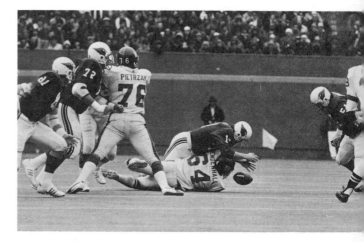

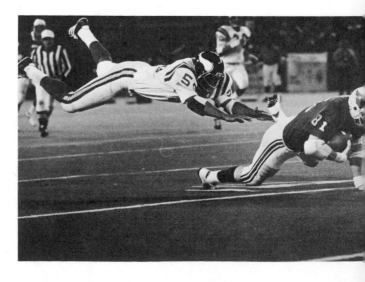

The photojournalist works at extraordinary mental and emotional speed—as at a professional football game.

The Challenge to a Photojournalist

For the photojournalist, a camera provides an instrument of reportage. He goes into a news assignment with camera, lens, and film as his special devices. His final form of communication with a mass audience is visual.

Yet, the photojournalist works with the same basic commodity—news—as his fellow word-reporters. He seeks the same news values, news ideas, peak points of news, and human interest. That similarity is not carried through to the end product—publication of news. For one thing, the photojournalist generally becomes much more deeply involved in his assignment. A word-reporter can be to some degree standoffish from the epicenter of news and still get a strong story. A photographer, however, must get close as possible to his subject matter, to the point in most situations of invading someone's territorial imperative—someone's public, personal, or social "inner distance."

For another difference, the photojournalist is much more visible in his work. High visibility—he can be identified by the presence of his technology. His act of reportage is one identifiable, overt, and even intrusive, whereas the word-reporter could blend with the event if he so desired.

Physically, the photojournalist works in closer proximity to the news, even to the point of possible physical hazard. The word-man could stand back, spectatorlike, even physically removed from the locus of action and hazard.

The photojournalist works at extraordinary mental and emotional speed, his visual receptors absorbing multiple images every second. Almost instantaneously, he selects a few rich stimuli to record on film.

The photojournalist also works with a more emotional and therefore powerful form of communication than does the word-man. He knows about the total perception of a photograph by the viewer who scans and assimilates the visual image, much of it subconsciously, encoding every minute detail of the picture although responding overtly to perhaps only part of it. No combination of words achieves that totality, that unpredictability, too, of response.

The iconic mode . . . this visual art the photojournalist isolates and records every day from such mundane circumstances as sports events, meetings and conferences, newsworthy persons, and environments. He is confronted daily by a massive challenge to his technological virtuosity, to his visual quickness, and to his visual creativity.

Those last two elements of effective photojournalism—visual quickness and visual creativity—are of concern in this book. Through contact with a series of photographic images and word discussions of those images, the reader should enlarge his own grasp of—and dedication to—reporting by camera.

An Animate World

A student of photojournalism was debating with an art student, the former arguing for a world of people, the latter defending a world of photographable inanimate objects. The photojournalist did not want his photographs to look depopulated, as though from another planet. The art student, however, found pleasure in the tactile responses he got from nonpeopled pictures of surfaces and textures.

The argument continued. The photojournalist wanted the realistic, identifiable, person-centered photographic image. The art student, in contrast, wanted the more abstract image stressing shapes, volumes, textures, colors, and tones.

The two could never agree, because they had dedicated themselves to different modes of expression with a camera. One mode is as valid as the other, yet each relies on different techniques provoked by different content objectives.

This snow scene (opposite page) illustrates an essential demand on photojournalism as compared to the demands on other areas of photography. The presence of people! The photographer while walking through his hometown after an early-Sunday snowfall and while looking down from a slight sliding hill in the city park, was affected by the aesthetic power of the scene: the shapes, the black-white tones, and the arrangement of lines before him. Black tree trunks were contrasted with fresh white snow. A graceful arc of snowfence was apposed to the curved outline of a snow-covered pond. The scene would have pleased any kind of photographer.

Yet, for the photojournalist one more element was needed to complete the picture. A person. The scene needed to be brought to life; it needed to become animate. He did photograph the scene as he found it, at least to get it on film. Then he returned later in the day and was pleased to find youngsters sliding on the hill. An abstract image was enlivened; with people in it, it now fit all the specifications of photojournalism.

He stayed an hour, exposed several rolls of film, then in the darkroom selected for printing this image of trees, pond rim, snowfence, and three youngsters with sled. He used high-contrast, number six paper to increase the contrast in tones, to produce an image of blacks and whites.

Do not assume that the photojournalist is disinterested in aesthetics. At the same moment that he records on film such elements as data, human interest, motion and movement, news points and environment, he tries to put into his instantaneous images as much line and shape and volume and tone and color as possible. He cannot concentrate solely on the aesthetics of imagery, however; he must try to grasp them simultaneously with a newsworthy image. His task, therefore, is doubly more difficult than that facing other photographers.

Here the photographer caught the people-impact of a weather picture. He also induced aesthetic value by shooting and reshooting the scene (film is the cheapest commodity of photography) until some sledders moved into perfect position to mix with the natural composition of the scene.

The people provided the indispensable bit of content. Without their presence, the photograph would not come from photojournalism.

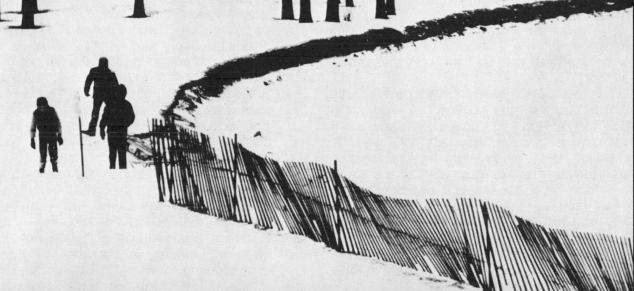

Exploring Total Space and Time

There is a photographic ratio of success that might be calculated this way:

The more the total time and physical space of an event are explored, the greater the chance of finding an original photographic image.

The more—the greater, thus a positive ratio.

Most news events occur in an envelope of total space. A speech occurs on stage, in the entire meeting room, backstage perhaps, in the entrance foyer, maybe on the street as speaker and audience arrive. Each area of the spatial envelope provides different opportunities for news images.

Similarly, a human-interest assignment can include, in total space, where the person works, his home, his areas of recreation and leisure, his cafeteria, his bar. Again, each area provides different image content.

To a photojournalist, exploring total space is like flipping a kaleidoscope; each twist produces a new image.

At a track meet, therefore, tired of finish-line histrionics, this photographer decided to explore the other space of the event. For one of the dashes, he got to the starting line. Here it was not a wildly flailing, body-twisting finish he planned to photograph; it was instead a spring-like, explosive, up-and-out thrusting action. He was not going to photograph a depthless, limned, tightly composed finish of the 100-yard dash; he was going to formulate an image of considerable perspective (the track stretching into the distance) with a considerable loosely organized and open space.

For the photograph, technological details are simple. A slow shutter speed (1/125th of a second) encouraged some action blur. A small aperture (probably about f.16) ensured a sharp focus from foreground to background. A semi-wide-angle lens (35mm) pulled in the full space of the loosely composed scene. By standing on a stool for a high camera angle, the photographer sorted out the lines and shapes in the picture.

This necessity for constant movement on the part of the photographer, to search out every niche and cranny of the event, is matched by a demand for total time involvement. The longer a photographer can work with his assignment, again the better his chances for an original photographic statement. Before the event, during, after—all of these time warps afford different photographic opportunities. Moods of an event change with time. Sunlighting changes in color and intensity and emotion. The action changes. The photographer, through time involvement, understands the subject matter better. He even gets time to experiment with images. He can also work with one idea for an extended time, working it out to a more perfect state.

To cover a news event with camera, come early.

Stay late.

Keep on the move and explore *total space.*

This is the surest way of avoiding photographic clichés.

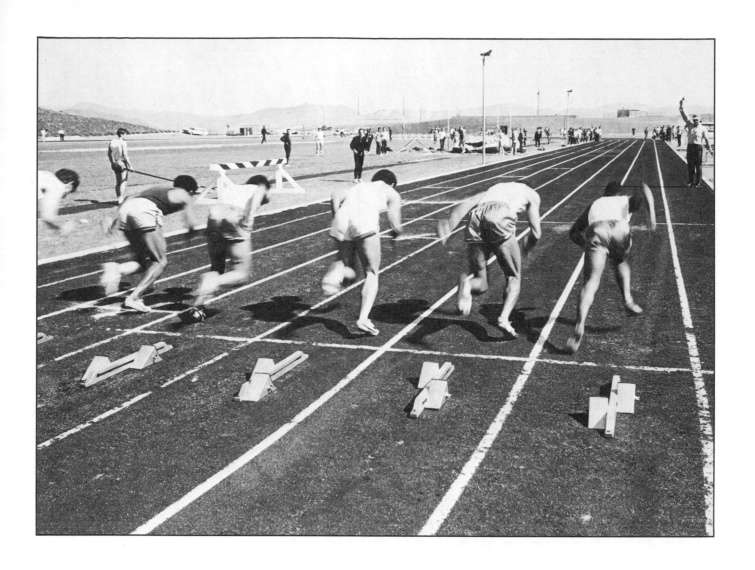

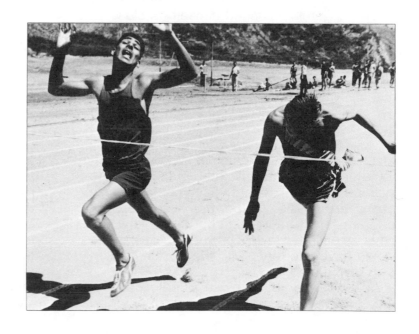

Getting Inside the Image

To photography there should be a feeling of "centrism," that whatever you are picturing is swirling 360 degrees around you, that you the photographer are situated at the eye of the scene rather than out on its periphery, that whatever is happening in your camera's viewfinder is spilling over and past the lines of that viewfinder, that something is taking place before you, beside you, and behind you.

When you the photographer are inside the image, you later pull the audience into that center with you. You try to avoid the indifferent point of view of a spectator. What you see in your viewfinder eventually is what the audience sees. In a sense, the audience looks into the viewfinder of the camera with you.

To photograph the finish of this track race, the photographer pushed himself as close to the action-center as possible. He elbowed his way among judges and timers on one side of the finish line. He leaned ahead to get even closer to the runner's finishing lane. He put a 35mm semiwide-angle lens on the camera to get maximum depth of field. There, amid the gaggle of officials waiting for the finish of the race, with the entire track meet momentarily focusing on this small patch of action, the photographer came into intimate contact with the visual message. He could have opted for only one better position, a foot farther to the right, on the asphalt track itself; but there he would have been ruled away by the officials or he would have interfered with the honest conclusion of the race.

As it was, he got as close as practicable to the epicenter of action.

He had to calculate his technology to be sure to catch the best news image—the winner breaking the tape. He prefocused the camera at the spot where runner would contact tape. He stopped down to get as much depth of field as possible; he needed a fast shutter speed to be sure to stop the runner close up (at least 1/500 at f.11 on Tri X film). He held the camera firmly out in front of his eyes so that he could turn his head left to watch the runners coming down the track. Then he could anticipate the split second before the winner moved into his viewfinder. He let the motion move into the viewfinder.

Part of successful news photography is tracking down these small areas of impact images, penetrating their perimeters as deeply as possible, once inside using the wide-angle lens for closeup work, stopping short of the exact action-center only because of hazard or inexcusable intrusion into the event. All this forward pressure gives the audience an empathetic, dynamic, hear-the-thud-and-smell-the-sweat experience.

A student photographer forgot that aggressiveness when assigned to show in photographs the crowded conditions of stairways in his school. He stood at the top of the stairwells, clear of the jostling and the shouldering, and his photographs conveyed no feeling of claustrophobia. He reshot the assignment from the middle of the stairways, with an ultrawide-angle lens (24mm), feeling and hearing the tumult on all sides. His next set of photographs contained the bumps and imprecations of the scene. He got images that communicated information *and* feeling.

He took the viewer to ground zero.

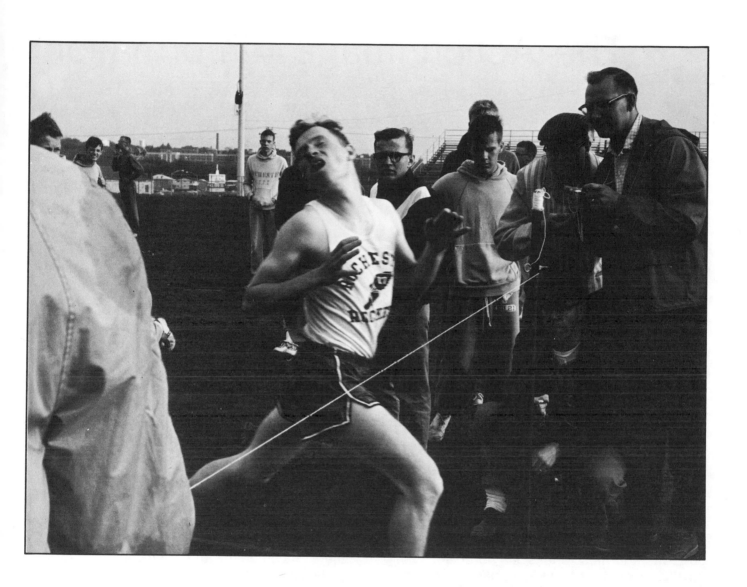

The Action Image—Information

The Renaissance artist became more and more excited about exploring a visual world that went beyond the conscious perceptions of human vision. The human eye can transmit neural information to the brain at the rate of 60 to 100 meters per second; yet, much raw action is perceived in a blurred state, and only the ability of the human mind to deceive itself communicates a message of action stopped.

It was, for instance, the artistic capability of posing action in midmovement, of "freezing" it, of showing the tautened ligaments and the undulating musculature, that excited the Renaissance artist. To enhance his understanding of frozen movement, the artist studied anatomy. He studied body language, too, the nuances of gesture and expression—the half-gesture of hand, the cocked elbow, the slant of torso. He was eager to delineate action in all its minute and realistic details. In his hands, art became animated, human figures were unstiffened, and scenes were swept with movement.

Four centuries later, along came the camera with its shutter speeds calibrated in microseconds. Even a beginner who merely pointed the camera at movement could freeze body angulations and muscle tensions no artist could have perceived. Realism in art declined in significance, the camera usurped its purposes, and the dispossessed artist sought escape in the challenges of vagueness, like abstract expressionism.

Mechanically the camera performs a miracle every time the shutter is released. It imprisons for the lifetime of the negative a microsecond of time. It splits off of mankind's continuum slivers of moments that no eye, no intelligence otherwise could have *consciously* comprehended.

It is miraculous what the camera does! Millions of photographers in the world feel the power of the camera, recording memories, extracting from a scene precise data to be contemplated later, pronouncing on print paper all kinds of messages and meanings.

This stop-action scene from a rodeo was sliced out of man's timeline at 1/1000 of a second during a warm, soft September afternoon at Carson City, Nevada. To get to the center of action, the photographer straddled the top rail of the fence next to the chutes out of which riders and Brahma bulls charged in dust and bellowing confusion. This particular rider was tracked bounce by bounce through the camera's viewfinder until the action reached a point of maximum intensity and meaning. Then it was frozen in time.

Bull won.

Rider flew off.

Rodeo clown moved in to divert the bull.

The hot dust swirled upward wherever it was touched.

An outrider moved in from the far rail to crowd the bull out of the arena.

Every stretch, every jot of kinesthetics was there, recorded by the simple photographic techniques of (1) selecting a fast shutter speed; (2) keeping the center of attention—rider and bull—in the center of the viewfinder; (3) anticipating this particular peak moment; and (4) pressing down the shutter release.

Thus, much of what the photographer of news does easily today is what the Renaissance artist desperately hoped to accomplish —to stop the world in order to reveal for the first time to human vision all the hidden, blurred secrets of movement; to record such details and information for immeasurable contemplation.

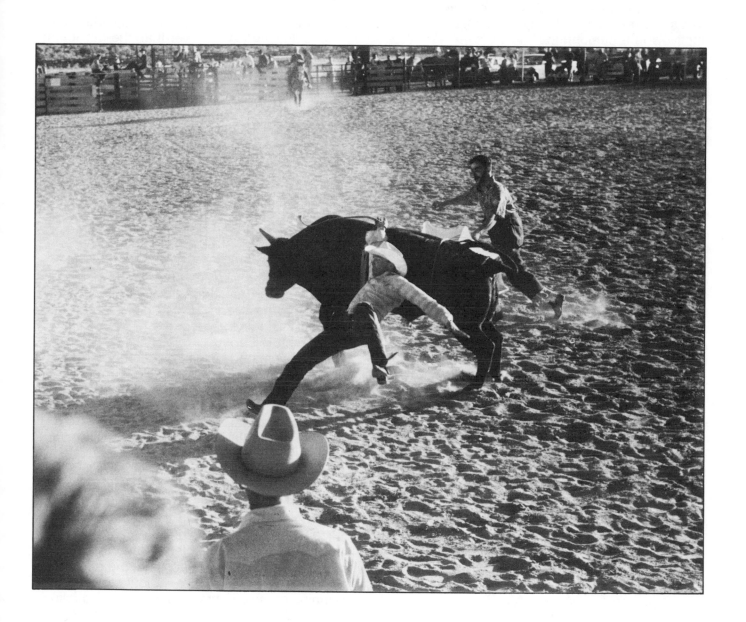

The Action Image—Emotion

Ideas can move in circles, despite the logician's insistence that thought progresses deductively in a straight line.

The course of action image in photography, for instance. It went from blur to stop-action back to blur.

In the 19th century image blur was omnipresent. In the 1840's, for example, photographic materials were so insensitive to light that a dozen minutes could be needed for a portrait taken without direct sunshine. Well into the 1930's film speeds ranged to only 200 ASA. Therefore, until the 1930's at the latest, the frozen-action image was difficult to achieve —except for exposure by stroboscopic flash.

When technology from the 1940's on made stop-action as easy as setting a shutter speed at 1/500, photographers ransacked the planet for matter to immobilize (again, changes in technology radically altered imagery). Stop-action, however, doesn't look like action. It resembles statuary. Although the detailed information provided by stop-action is fascinating to study, the image seems unrealistic. Even more, there is no mood nor impact nor emotion to it. Movement becomes immobility, a serious contradiction.

The circle was enjoined. The photographer in the 1950's reverted to incorporating blur into his motion images. He joined ranks with the comic-strip artist who, to give the sense of movement to his cartoons, draws in thrust-lines, like this:

Action is not action unless there is a sensation of image in movement. Because of the complexity of modern technology, the photographer can vary such movement effects. He needs only to compute these three elements:

1. Decide the amount of movement blur he wants to record; the more the blur, the more the sense of action.

2. Determine the maximum shutter speed he needs to freeze the action in his viewfinder.

3. Calculate a slower-than-the-maximum shutter speed, thus accomplishing (1).

If he is directing his camera from a balcony down on a group of folk dancers rotating at different speeds—a fast-stepping ring on the outside and a slow-moving ring on the inside—he could freeze both rings at 1/500 or even 1/250. Yet by shooting at 1/60 or 1/125 he could freeze the slow inner ring and blur the outer ring.

He can bracket his shutter speeds (1/30, 1/60, 1/125, etc.) to randomly arrive at a most effective degree of blur.

The photographer also can "pan" for movement effects, as in this photograph of a low-hurdles race. Panning laterally blurs the background in the scene. It also blurs foreground runners to varying degrees. The sense of movement is strong.

For this panned image, the photographer stationed himself next to the track, perpendicular to a row of hurdles. He prefocused the camera on lane 2 directly in front of him. He set the shutter speed for 1/100 (a tenth of what he needed for stop-action). Then without changing prefocus or shutter speed or his station, he turned the camera toward the starting line and centered the runners in the viewfinder. As the hurdlers raced toward him, he "tracked" them in the viewfinder, moving the camera to keep pace with them; he moved the camera at the same speed as the hurdlers. When the hurdler in lane two reached his position, the photographer released the shutter without stopping the panning of the camera, and continued to follow the hurdler down the other end of the track.

(For other images panning is possible vertically or in circles.)

The blurred image provides only basic details to the audience. Thus, it becomes considerably abstract as an image, largely emotional, even somewhat symbolic. The viewer of the photograph is not so much concerned with details of the musculature and the gestures and expressions of action as he *feels,* he senses, the motion.

Audience reaction is not intellectual in this case; it is directly muscular.

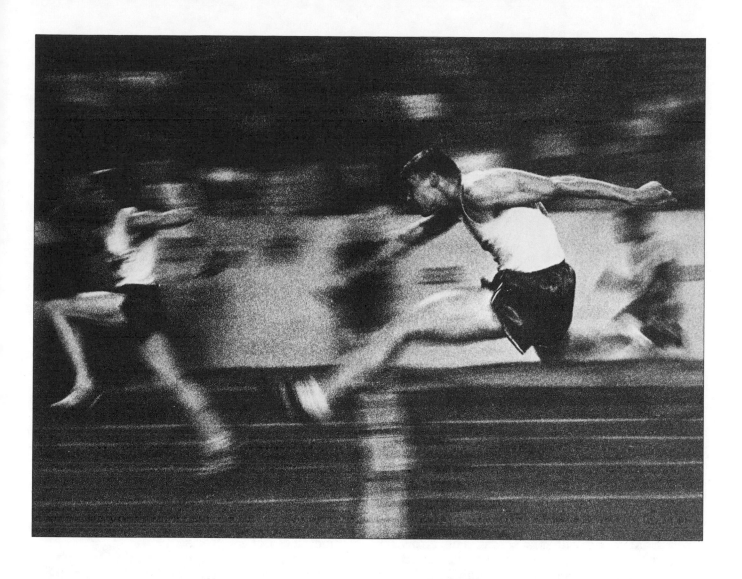

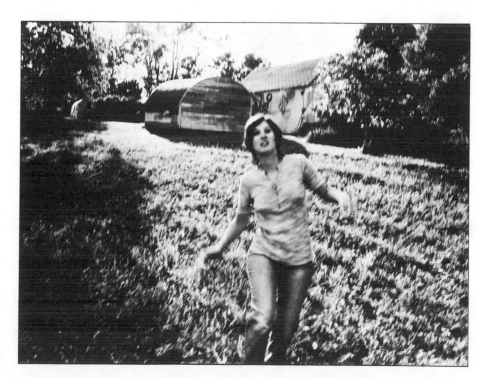

Very slow shutter speed (estimated $1/15$ of second) led to overall camera-movement blur.

The Precise Moment

For days as he walked downtown and back home again, the photographer felt uneasy about the great white stone wall with looming on it the mysterious black arrow. The arrow overhung a small parking lot at a busy intersection, and it may have been a remnant, somehow never painted over, of a much more elaborate advertisement.

The unease grew as the photographer pondered what to do with the scene. The arrow hovered there, out of context with the street corner. A few attempts to photograph it resulted in inconsequential images—a great arrow on a stonewhite wall.

Photographers constantly are irked by indecisive images, when something more is needed to close the circuit of a picture.

Then one day as the photographer stood across the street, once again researching the scene for completeness, a pedestrian strode under the arrow. The circuit snapped shut. In a second of time, arrow and white wall and human figure came together in precision of meaning. The photographer prefocused on the arrow, selected an exposure setting, and waited for the next pedestrian to pass under the arrow.

The elements meshed visually to make an ironical statement—man pursued and marked relentlessly by fate. No passerby can escape detection by the arrow. Everyone ultimately and ineluctably must be pinioned by it.

The composition of the photograph is precarious. Move the pedestrian left or right and the arrow ignores him. Take away the several lateral lines and the arrow seems less persistent in its pursuit of the man. Straighten the pedestrian's shoulders, bolster his head, or shorten his stride and he seems less burdened by the arrow. Clutter the white wall with shapes and tones of bricks and the arrow loses dominance. Take away, change, or lessen any of the elements and the moment is undermined in its effect; it is not as precise.

These special moments are sought by photographers with the fervor of the Knights of the Round Table seeking the Holy Grail.

The photographic philosophy is this: Every action moment, every romantic scene, every portrait can be heightened in visual strength by the photographer's identifying those exact juxtapositions of content in his viewfinder, by his exposing the film at those precise points of time.

To photograph moments at random, at mere accidental intervals, would result in largely irrelevant, even disparate, content that forms garbled visual messages. A photographer might as well mount his camera on tripod and set an intervalometer to trip the shutter every so many seconds.

But to pick and choose—at split-second speed—those precise moments of content harmony when data and composition seen in the viewfinder of the camera fall into perfect relationships—ah! that is the challenge.

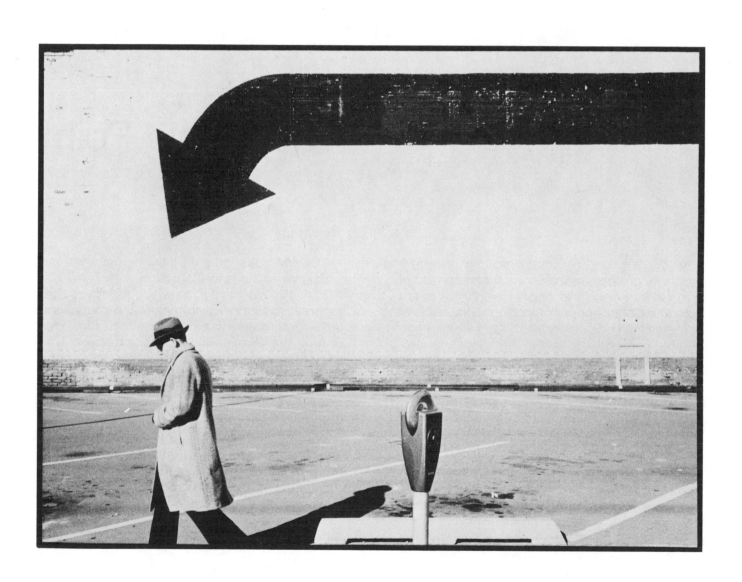

The News Point

Much of a photojournalist's work is redundant. His professional existence can consist of a repetitious round of sports events, of meetings and conferences, of visiting dignitaries, of accidents and disasters. Yet, he is challenged by the necessity to avoid repetitious photographs. And always he is uncertain how far his imagination can stretch to find an original image at his, say, hundredth football assignment.

His salvation, as well as an obligation, is seeking "news."

"News" is what elevates this photograph above the category of cliché—that is, just one more picture of an end catching a pass. It happens to be a pass reception for a touchdown (news of achievement)—note the goal posts and the cross stripes indicating an end zone. It happens to be a game-deciding touchdown (an even greater achievement). It is caught by a rookie flanker who later received rookie-of-the-year honors from the National Football League. The photograph is resplendent with "news."

In other words, this is more than a routine photograph of football action; it is a newsworthy moment in the game.

It is the news inherent in such split-second photographic moments that helps a photojournalist avoid a lifetime of visual clichés.

The first question asked by an editor will be: "What've you got that's newsworthy?"

The photojournalist answers with a photograph: "Here's the point where the roof of the warehouse caved in early in the fire." Or: "This is how the President told the nation he was declaring gas rationing; this is the exact moment he announced it on TV." Or: "Here's the touchdown pass to Flatley, just as it's settling into his hands and he's coming down in the end zone."

The photographer must be trained in news values. He understands that news means a dramatic moment, a moment of personal effect on the reader, a deciding moment, a moment of success, a moment of tragedy, a moment of humor, a picture showing the unusual and the different, showing as a record a scene of news (as at a fire), showing a familiar face, showing a person deeply involved in the news.

At the same time that he seeks pictorial originality at an assignment, he keeps one compartment of his attention directed toward news values. Like the word-reporter, he constantly asks himself, "What's my lead here?" If the answer is, "Flatley catching the winning touchdown," he puts that answer down on film.

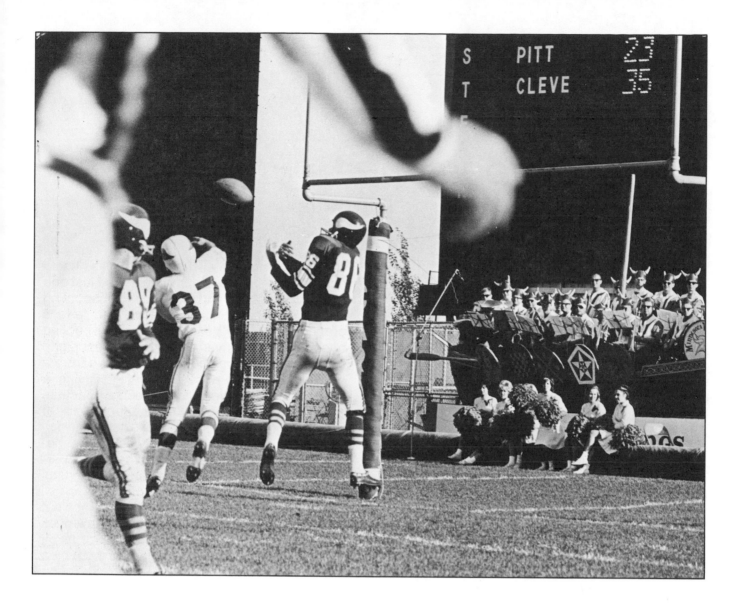

Wisconsin crew team after winning the national championship throws its coxswain into the water, a tradition in the sport.

Photographer's Point of View

There once was a photojournalist who worked from his knees to depict a day at kindergarten. He wanted to see and feel that world from the point of view of a 5-year-old, world looming above him, teacher a giant, windows and light fixtures inaccessible. By selecting an unusual photographic point of view, he produced a set of visual reports that in turn thrust the viewer into a youngster's world.

(Wherever the camera goes, the viewer is sure to follow.)

At a track meet for the picture on the facing page, the photographer got tired of the usual stand-up, look-straight-ahead, physical point of view. So he climbed to a balcony overlooking the final straightaway for the running events. He could look down on the action. He had ascended to a unique point of view. His audience climbed with him.

The results of aerial view are several. First, the audience is confronted by a new and in its novelty more interesting portrait of a routine sports scene. Second, a high angle tends to sort out and accentuate the compositional strengths of a scene. Third, in most cases subject matter is "posterized" against a neutral, noninterfering background—usually floor, ground, sidewalk. Fourth, the viewer feels greater muscular tension looking down on something, to varying degrees the sensation of height being inescapable.

Another strength—an arbitrarily selected point of view helps rid recurring assignments of recurring images.

Some professional photojournalists like Neil Leifer of *Sports Illustrated* magazine are expert at calculating and creating distinctive points of view. For basketball he has mounted a motorized camera with a 50mm lens, all remotely controlled, immediately behind the glass backboard. In football he has photographed just one player from start to end of game. For iceboating he has stationed himself, with wide-angle lens on camera, at the nose of the boat, shooting backward at the driver as the boat swept along the ice. For baseball he has shot down from a gondola 210 feet above the infield, using a 180mm telephoto lens to get closeup action.

Another sports photographer, George Silk of *Time-Life,* has become as well known for distinctive approaches—whether physical, thematic, technological, or psychological. In particular he devises special cameras and lenses for extraordinary, original action images.

Mark Kauffman of *Sports Illustrated* once put two 35mm cameras with ultrawide-angle lenses *inside* the nets of a hockey game, at ice level, just behind the goalie, and triggered them by a remote switch.

As for the kinds of point of view, **a physical approach** would place the photographer in some unusual spatial relationship to his subject matter—such as shooting track from a balcony.

A **thematic point of view** involves choosing a previously unexplored idea—such as Leifer photographing during a game one player of special importance.

A technological point of view involves the selection and innovation of special equipment, film, chemicals, and darkroom techniques to create an unexpected visual image.

A psychological point of view stresses a mood or emotion inherent in the subject matter—such as the loneliness of old age. An emotion might be conveyed, too, by the technique of the photograph itself—with silhouettes, with high-key or low-key tones (all dark tones or all light tones), or with grain-filled, texture-heavy finishes.

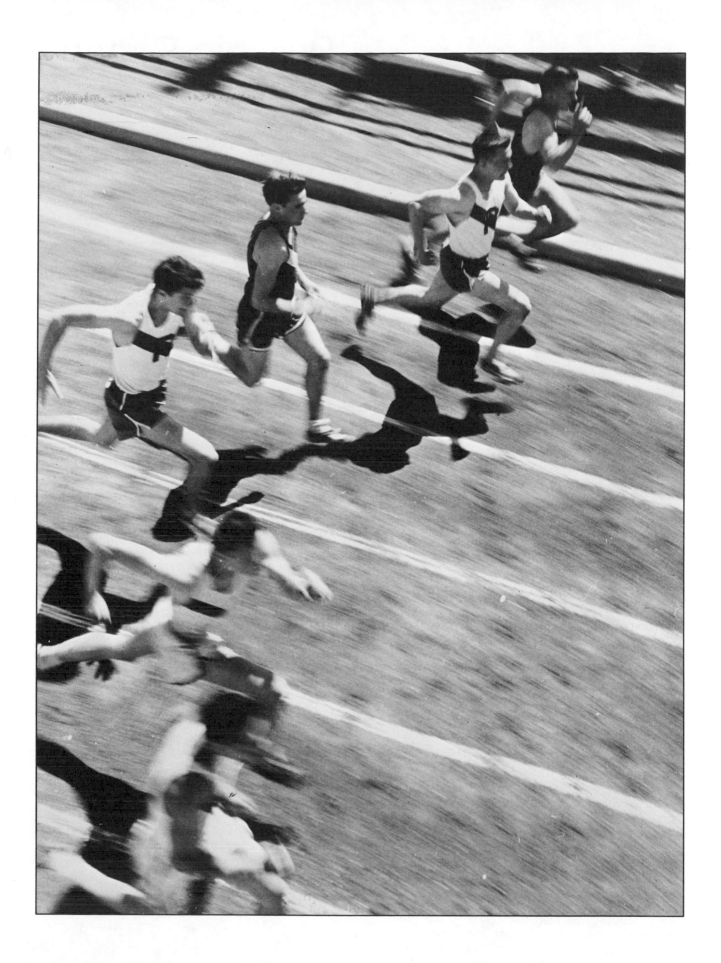

Psychic Distance

A photograph as a visual image should remain as wordless as possible. As a visual image it appeals more to emotion than to intelligence, more to subconscious assimilation than to rational understanding, more to psychological communication than to logical.

A photographer communicates at close psychic distance with his audience.

Psychic distance: this is the *emotional closeness* a viewer feels toward a photograph. It is not physical distance measured in so many inches and feet. It is how much the photograph reaches out, grips the viewer by the nerve endings, and pulls him in close.

Psychic distance is not measurable, but it is determinable. For instance, action moving directly at the viewer reduces psychic distance to a minimum. For the barrel race at a rodeo (the photograph on the opposite page), the photographer chose a position at one end of the arena where as much as possible the action would be thrust directly at him. To avoid physical danger, he chose a 300mm lens that put space between him and the rider. By selecting this physical point of view—not a complex decision—the photographer ensured a straight-on confrontation for the viewer. He attempted to communicate with the audience as much as possible by the central nervous system.

Unfortunately for news images, too many photojournalists prefer to be passive spectators, and they transmit that neutral, nonconfronting personality to their pictures. Psychic overdistance results. In newspapers, note the number of photographs "taken from the side": shots of ears and backs of heads, action planes crossing the picture laterally and flatly, an overall remoteness from what is occurring. Much of the potential of communication has been wasted.

This lack of tension of confrontation often is caused by the photographer's own desire for anonymity, noninvolvement, and placidity.

Without question, therefore, the simplest method of closing psychic distance is to select, as much as possible, a confrontation with the action, with the scene, or with the person, whatever the fundamental content of the photograph. (See the photograph at bottom right.)

Photojournalism demands keeping in front of the action.

The next easiest thing is to become aware of body gestures and facial expressions, which when sharply defined and directly looked at lessen psychic distance between photograph and viewer. The gritty look of determination on the rider's face, for instance, exemplifies such connotative communication. When you talk to another person, at the same time you are listening to grasp his words you respond emotionally to his frowns and squints, to his pointing and starkly accusative finger, to his smiles and pouts. A photographer, too, watches in his viewfinder for those vital expressions and propulsive gestures. He knows that a hand thrust directly at the lens becomes a thrust into the face of the viewer.

A third point: any plane that is projected forward or diagonally in the photograph reduces psychic distance. The weakest plane runs parallel with the flat surface of the photographic print. A stage designer understands fully that principle of thrusting planes; instead of arranging a table on stage so that its front side runs parallel with stage front, he sets it at an angle so that one corner will poke sharply at the audience. As for the picture of rider and horse, the plane of their coordinated movement runs perpendicular to the surface of the print, directly *at* the viewer.

Still another way of closing up psychic distance: a low angle augments emotional reactions from the viewer. People or scenery in the photograph loom over him. Action threatens to overrun him. Photographers too much work from a stand-up, look-straight-ahead viewpoint. It would be better for effective psychic distance to work from bent waist, or from knees, or even from prone position on the ground. An old, old rule of photography says this:

Low angle for drama.

High angle for composition.

A fifth point: working close to subject matter cuts psychic distance. Think of the camera this

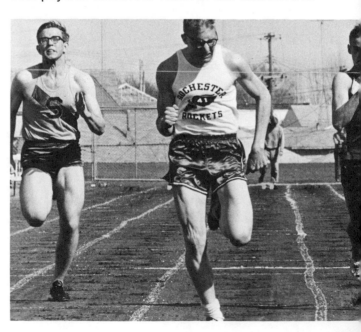

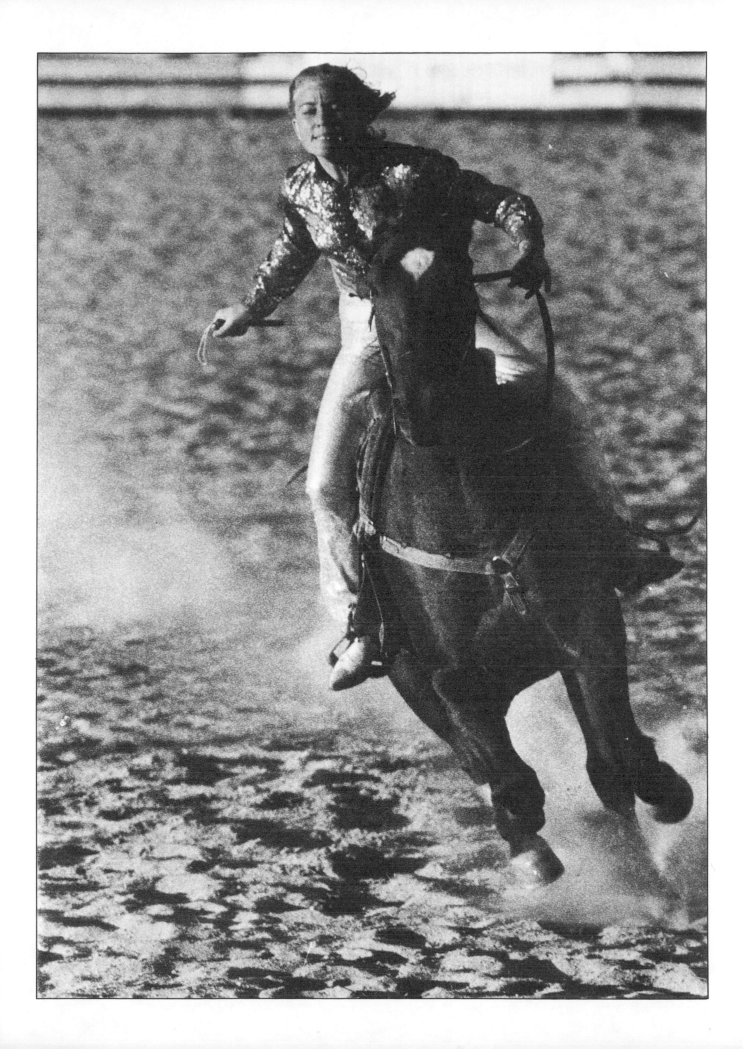

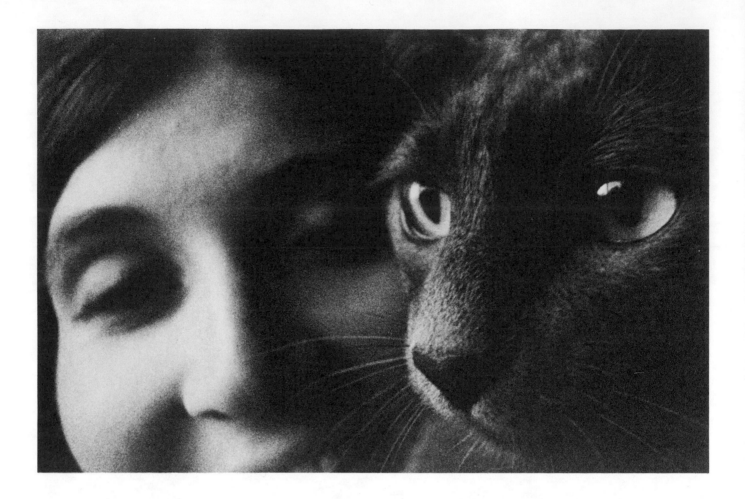

way; it physically represents the eventual viewer of the picture. If the photographer chooses to work outside a crowd at a political campaign, for instance, the eventual picture audience stands there with him—outside, detached, largely impersonal about what is happening. If the photographer sallies into the crowd, with perhaps a wide-angle lens permitting extremely closeup work, if he decides to photograph from the vortex of the event, the viewer goes along, gets jostled, feels action swirling around him, gets caught up by the nervous system.

In addition, there is the opportunity for infringing on a viewer's territorial imperative. That really diminishes psychic distance. Each person tends to draw an imaginary circle around him and some distance away from him into which he does not want others to penetrate. The camera can subvert that defensive imperative, especially through the use of telephoto and wide-angle lenses, to bring the visual image uncomfortably and unnaturally close to the viewer. One reason for a tightly composed photograph of a face, stripped to eyes and mouth and some hairline, is to violate the territorial imperative of the viewer and perhaps reset a new one. For the ultra-closeup picture of cat and woman, the photographer added an extender to a normal lens so that focus became a matter of inches. Beyond that technological

necessity, there was needed only a cooperative cat. An ultrawide-angle lens (20mm, for instance) would have served the same purpose. Some other ways to lessen psychic distance:

• Instead of photographing the total scene, select small parts of it, turning isolation and intensity of imagery into greater impact on the viewer. Photojournalism is the art of closeup imagery.

• Seek eye contact with people. Direct eye contact for a speaker and a photographer alike establishes taut communication. And it holds that attention.

• Respond quickly to movement, a priority in news. A kinetic world is more exciting and involving than one static. Photojournalism is a world of dynamics for that reason (notice the kinetics in the photograph of horse and rider).

• Appeal to the senses, with viscerality intended. Blood, sex, anger, heroism, patriotism invite quick sensory response. A photographer seeking viewer response appeals to the sensate.

• Be quick to identify symbolic content in a scene. The power of symbolic detail is awesome and can close psychic distance—especially status symbols, those common reference points of existence that people identify with or against, such as hair styles, flags, automobiles. More powerful are the deeper, mood-provoking symbols like sun, grass stirring in the wind, lake framed in trees, youth. The ability to identify and

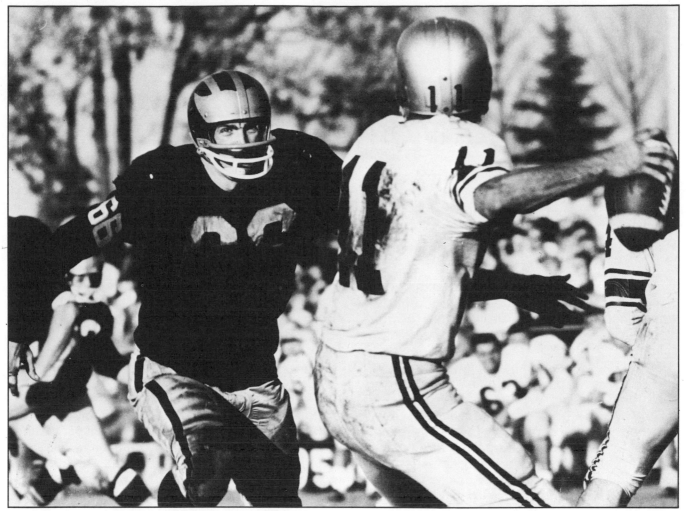

Keep in front of the action.

Look for forward planes.

utilize these referential and empathetic details is the last to develop (no pun intended) in a photographer's sense of vital image content.

● Be willing to explore with camera the intimacy and privacy of human existence. A photographer realizes that to his audience there is insatiable curiosity, there is compassion, and there is need for vicarious experience. He uses camera to pique curiosity by exploring subworlds and little-known patterns of living. He appeals to compassion by photographing tragedy, misfortune, and failure as surely as he does more triumphant modes of human existence. He satisfies the need for vicarious experience by photographing heroism, adventure, even antisocial behavior that the viewer otherwise would avoid.

The common problem of most photography is this:

Word-people when they pick up a camera remain word-people. The psychic distance of words generally is "over-distance," with little direct emotional impact to them.

Those trained in territorial imperatives, in denotative values to communication, in the detached attitude of logical thinking, and those accustomed to spectatorial approaches to events and people—well, such word-people tend to restrict the camera.

A visual image is psychological, emotional communication first. The data, the logic, the rational expression come later.

The Moment of Recognition

—and Identification

One of the embarrassments of life is this one. The car breaks down in the middle of a multilane superthoroughfare. Traffic backs up for blocks. You are the object of considerable elocution.

Or the car grinds to a halt halfway out of the one exit from a drive-in theater. Horns honk back to infinity.

So when the photographer saw this scene unfolded in the center of Chicago's main street—State Street itself—he felt as uncomfortable as did the motorist dabbling under the hood of his car with patrolman looking over his shoulder. The moment of recognition, a moment every person who has driven a car identifies and empathizes with, this moment of universal reference a photographer is also quick to record on film.

In this case, however, a relieved laugh is part of the total response to the photograph, thank God it happened to someone else.

The photographer stayed at the scene for a good 15 minutes, photographing it anew each time some element shifted. A better arrangement of cars, for instance, swerving around the stalled vehicle engendered a new series of exposures. Motorist buried a little deeper into the maw of the car. The policeman shifted to a position of greater contribution to the total organization of the photograph. A pedestrian on the scene.

From the sequences of negatives, this one image told the story best, an example of *the photograph as narrative art*. From the data in the visual image, the story unfolds clearly:

A rain-filled night.
Busy downtown street.

Hood (trouble) and trunk (tools) up.
"Get a move on, buddy, you're blocking traffic."

The awful moment of recognition.

The photograph also exemplifies two of the three levels of viewer response to visual imagery.

The first level: a totally conscious response to data. The photograph is strongly informational, and the more minutely it is inspected the more data that can be accumulated. License number. Model of car. Christmas decorations along the street. Night. No passengers. This first-level response is the most direct, although superficial and simplistic.

The second level: the partially conscious identification with and personal reference to the photograph. The viewer identifies through experience with what he sees, all the way from pleasure at seeing a familiar location, to identification with what is happening, to possible overt neuromuscular reaction to gesture, expression, or action. The latter responses are referred to as empathy, such as happens during a kissing scene on the movie screen when the viewer might unconsciously purse his own lips slightly.

The third level: the largely subconscious, subliminal, deeply ingrained responses to the symbolic and psychological content and composition of the photograph. Rain provokes a particular third-level response. So do the harsh lights and shadows of the street and the presence of the policeman. A third-level response is retained by the viewer the longest; it is the most penetrating.

Overall, it is the intensely personal familiarity with this scene that sells it best.

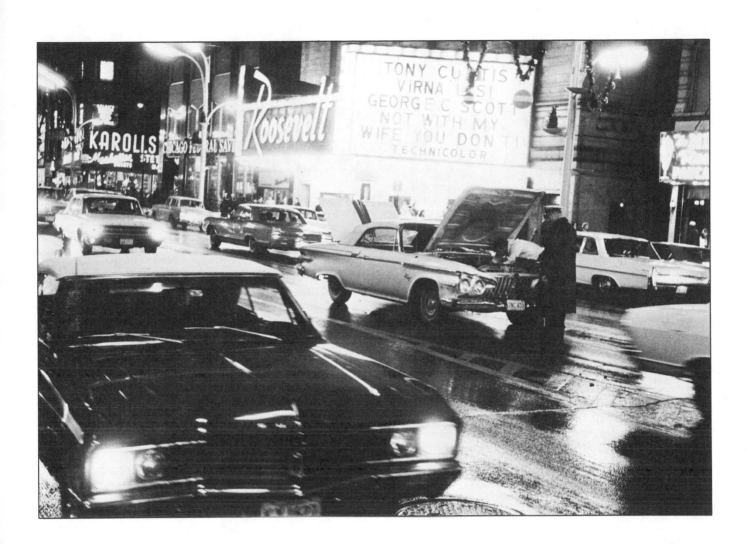

Technology and the Created Image

The photographic technology behind these two images is largely different. Both images were preplanned, and much of the planning involved selecting special technology.

A photographer learns that technology to a large extent governs content, or, to put it another way, that content is predetermined heavily by the apparatus of photography selected arbitrarily by the photographer.

The football image involves *selective focus,* a narrow depth of field caused by a combination of telephoto lens (300mm), wide-open aperture (f.5.6), and close proximity to the player. Selective focus is popular in photojournalism because it isolates a few details like the player's face, puts them in focus, then minimizes all other details by blurring them, throwing them out of focus. Selective focus is accomplished easily by deploying technology this way to reduce depth of field to a few inches:

1. Shooting with as wide open an aperture as possible.
2. Possibly using a telephoto lens.
3. Moving as close as possible to the content to be emphasized.

Selective focus is difficult with a wide-angle lens or with fast film in strong light.

Selective focus is natural to photojournalism that stresses isolating and emphasizing special details.

In the other photograph, a 35 mm wide-angle lens was used to create maximum depth of field; fast film and powerful developer to record the low-light night image; and a tripod to hold the camera still during a prolonged exposure of seconds.

The technology for the two photographs could in no way have been reversed; otherwise the images would have been radically different.

A photographer must understand "news."

He must understand the rational and the psychological impacts of visual images.

And he must be technically sophisticated enough to understand without reservation that Technology ⟶ Content.

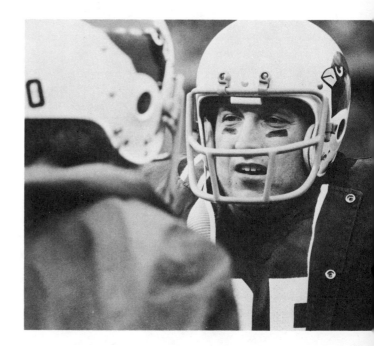

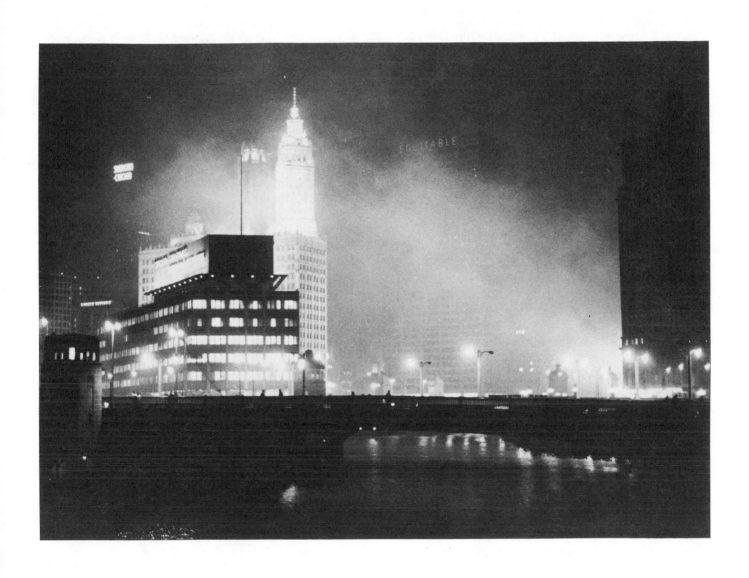

The Image of Romanticism

Romanticism is entertainment bent on the pleasure principle, designed to inspire in the audience a sense of well-being and confidence.

For periods of time romanticism has been autocratic in poetry, in films, in painting, in photography. In the certainty that art and literature must be inspirational, for instance, a poetry teacher will be adulatory toward Longfellow, Whittier, and Bryant but less than enthusiastic about Whitman. A photographer may be enthusiastic about smiles and sunsets and happy children, all romantic images, but shun the harsh realities of poverty and disease and ugliness.

This photographer sought totally the pleasantry of a summer scene—the calm of a mirror-surfaced lake, the companionship of people in a boat, the sweep of leaves and rushes and other summer foliage, the precise and orderly composition, the static effect of boats drawn to rest on the shore. All these elements contribute to a serene image, redundant in its warmth and familiarity, a pictorial confection delightful to contemplate.

Throughout much of the history of photojournalism this insistence on romantic images has prevailed. Photograph the "accepted" mode of life, not the subworld. Photograph enjoyment, not unease. Photograph faith and heroism and triumph and all the other flowerlike and benign symbols of comfort.

That romantic impulse can condition a newspaper's pictorial policy. One West Coast publication has an in-house rule that no beer cans nor whiskey bottles can be visible in any photograph, a sop to the publisher's sense of propriety. A great many discourage publication of images of death, even more so of blood. No shocks to the eye—such content disturbs the tranquillity of audiences. And so a parade of romanticism marches confidently across many front pages.

But a photojournalist, like his brothers the word-reporters, must surmount the autocracy of romanticism to confront reality, and if reality calls for shock rather than comfort, then the shock-truth must be published.

For one reason, to be remembered an image does not need to be pleasant. Disturbance can seep deeper into the human sensorium than can pleasure. For another reason, the sensation-inspiring image can cause more change in an audience's attitudes than the scrupulously uplifting photograph that mostly reaffirms attitudes. For still another reason, the photojournalist is committed to seeing the world in all its gross and scope, whether romantic or realistic. For another, the pictorial image possesses such pronounced powers of editorialization that it is a shame not to use it for all its potency.

Romanticism cannot be equated automatically with purity, moral elevation, and social conscience. Romanticism in excess can lead an audience to euphoria that, at times, must be overcome in order to bring about conversion and change.

Even winter is romantic

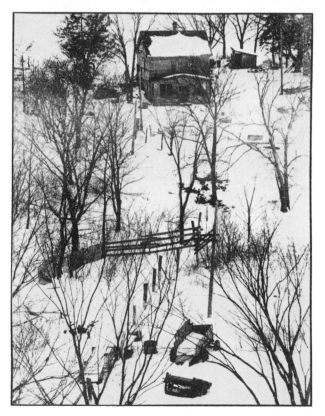

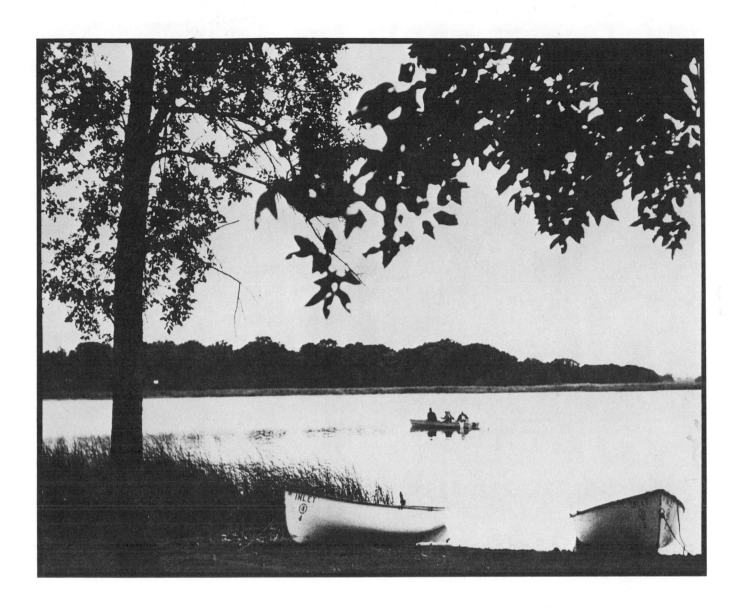

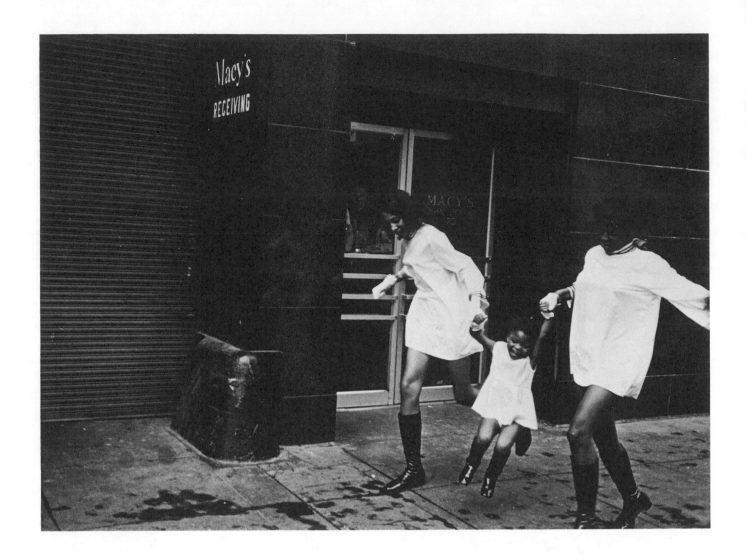

The Image of Realism

The romantic in art, despite his intention to create a kind of rewarding "truth" out of his own personal experiences, has incurred considerable critical wrath. Romantic vision, some persons have argued, lacks restraint, neutrality, the essential understatement that underlay the classical rules of fine art.

So a photographer cannot be certain that by sheer romanticism he can inspire universal acclaim. Some persons will always see in the romantic image (like the boats and lake on the previous page) excessive sentimentality.

A photographer, therefore, invokes a variety of moods in his imagery.

Realism is one such mood, seeking a true representation of the everyday world. Street photography provides a source of realism. This photographer was alerted by the visual image approaching him, two young women swinging a child between them. Their enjoyment was visually obvious, and it infused all the brief environments of their progress along a block in downtown San Francisco. They formed a typical, realistic slice of life.

The setting, too, exudes realism: the littered sidewalk, the observer casually and naturally leaning against Macy's door, the austere concrete background bleak in its promises.

Photographically, and luckily, the white garments of the persons contrast with the heavy tones of the rest of the scene.

Also, the image is not distorted by an overly conscious planning of composition, fine-grained details, and calculated darkroom additives like bleaching or printing in.

The photograph represents a perfectly honest, direct, everyday visual experience.

This type of realism the photojournalist seeks in much of his work. He saw the scene approaching, he quickly set his camera controls, he prefocused for a spot where the persons would pass before his viewfinder, he waited until they entered that zone, and he took the picture.

In the rain-soaked photograph below, another street scene looms in its honesty and realism. It was taken shortly after a midday rain in downtown Syracuse while the streets still glistened. The photographer was suddenly confronted by the bundled paperboy swinging around a corner. The picture was recorded instantaneously, as a reaction rather than from contemplation. While working the streets, the photographer preset shutter speed (1/125 to 1/250), tried to use an aperture that would provide some depth of field (f.4 or 5.6 or 8), used a 35mm wide-angle lens to get even more depth, and prefocused the camera at 6 feet in front of him.

In that way, the camera could be raised and the shutter released automatically.

The honesty of the image is augmented by the stand of rain-soaked Sunday papers, testimony to the weather.

It is a picture not crafted nor conditioned and only slightly calculated. It is experienced and recorded that way on photographic film and paper.

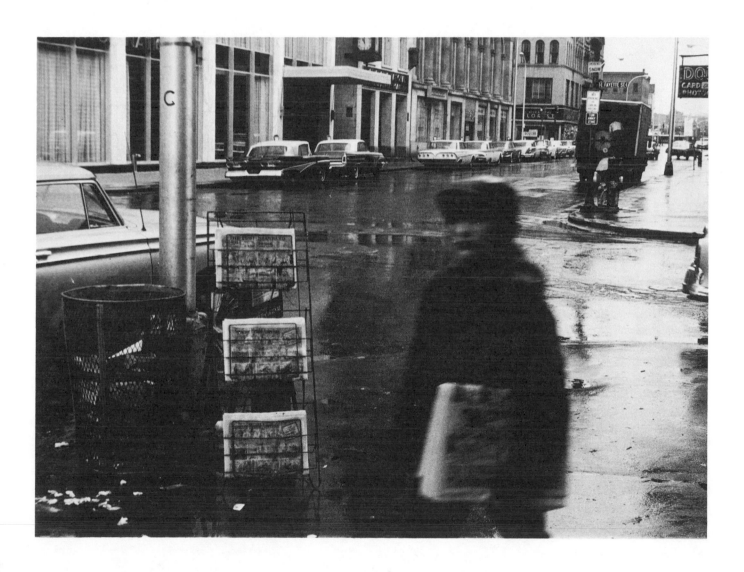

The Glut of Data

Speaking of the data-filled photograph . . .

This one is packed corner to corner with information, even to possible examination with a magnifier of every face embedded in the tiers of football-mad, sun-shadowed Minnesota fans. At the lower left, a placekick is under way, the football scant inches off the kicker's foot. At the middle bottom, a blocked kick is threatened by a white-suited player diving for the ball. At far right, the rest of the defensive line begins to break through the line of scrimmage. Farther back stand the coaches and substitutes, then the rowed fans in different postures and with different expressions.

Oh, yes, the action occurs somewhere near the 50-yard line.

The day is so hot and the sun so intense that sunhats are profuse, and a policeman (middle, bottom, rear) has shed his uniform coat and has draped it over an arm.

If you know football symbols, you know that the San Francisco 49ers are playing the Minnesota Vikings (the horned helmets).

This presence of data is demanded in the work of a photojournalist. To a certain degree, every photograph must tell about something newsworthy, timely, and of local interest. A photograph may show the deciding play of a game, the most violent moment of confrontation, the most significant moment of a speech, the place where something happened, or the person who was most instrumental to the event being covered. All this is "information"; it is photographic data and must be rigorously searched out.

In photojournalism, there is no such thing as random shooting, exposing several rolls of film and then in the darkroom—like panning for gold—trying to find a useful image to give to the editors. Images must be calculated on the scene for their news values as well as for visual impact, and recorded at that point with the expectation that they will prove rewarding to an editor.

For the photograph on the opposite page, the photographer could have called on a telephoto lens (300mm) to isolate only the kicker. Instead he wanted to show the play and the crowd. He submerged in this instance a relatively unimportant action moment for the greater strength of a record image.

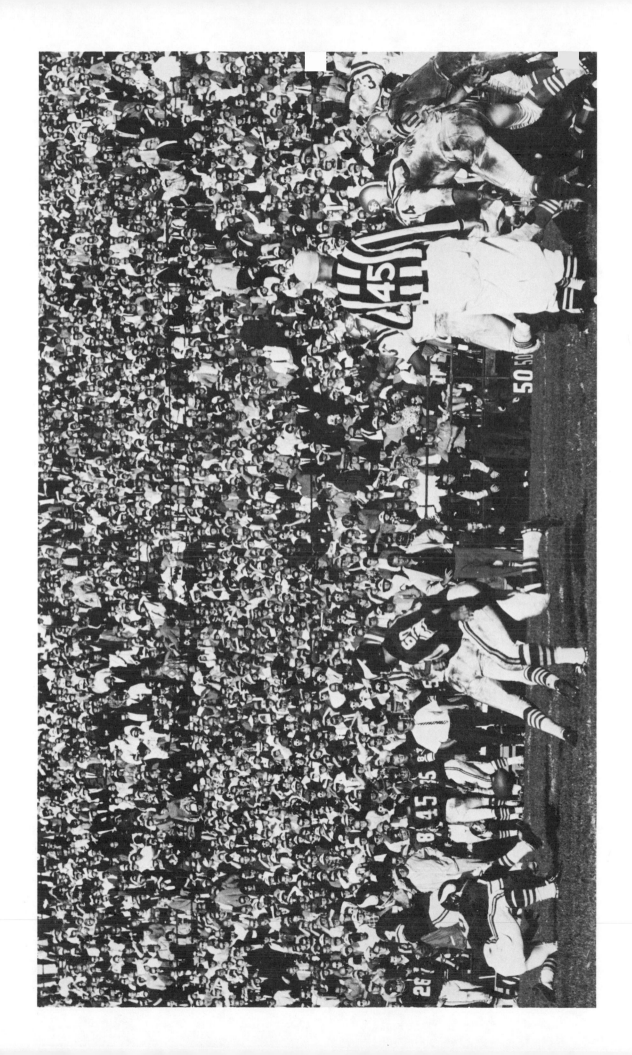

Light and Shadow

For the photographer, in the beginning was the light, not the word. Light provides his raw material, his elemental force. Without light to implant an image on film emulsion, there is no common photography.

A photographer, therefore, becomes an expert on light. For instance, at a rodeo this photographer chose to deploy light for richer effect. He had been working from the area of the stands seen in the background, with the lowering sun at his back. Then he circled the arena until he looked directly into the sunlight. Shadows fell forward into his lens, and mood was intensified. The action of bull-riding was semisilhouetted with edge-lighted shadowy shapes against the sunglare. Billows of dust rose from the floor of the arena and diffracted the sunlight into a series of spotlights falling on bull, on clown, and on fallen rider.

By using available light to its greatest dramatic power and mystery, the photographer turned a potential action-cliché into a fresh pictorial image.

It is one thing to be able to measure available light to arrive at a proper exposure. It is quite something else to be able to use light for visual appeal.

"Dollar-aesthetics" use light with little imagination. Those simplified directives usually insist that light sources be behind the photographer, excellent for even illumination of details, yet flat, dull, "limned," and unimaginative. More impactful lighting comes from the side of or above or in front of the photographer, as long as he has enough frontal illumination to define the subject matter.

The message is basic: if you want definition of details use frontlighting (light source behind you). If you want mood and impact, use sidelighting and backlighting (light source in front of you).

Those same basic manuals advise shooting by sunlight at midday when light is the most intense. Yet, the light is a greater actor when it is low and sweeping across the landscape and intensified like a great theater spot, as it is in early morning or late afternoon.

As for artificial lighting, most amateur flash units are designed to be fired from the camera. Yet, more mood-filled lighting results from a flash held high and to the side, at arm's length, of the camera.

So the photographer must *see* light. He studies its shadow effects. He studies its color (orange in late afternoon, bluish in winter, and so on). He studies how it delineates details.

He works around his subject, and as he revolves he watches light unfold its surprises. And he tries to plan a particular time of the day when light is most appropriate to subject matter.

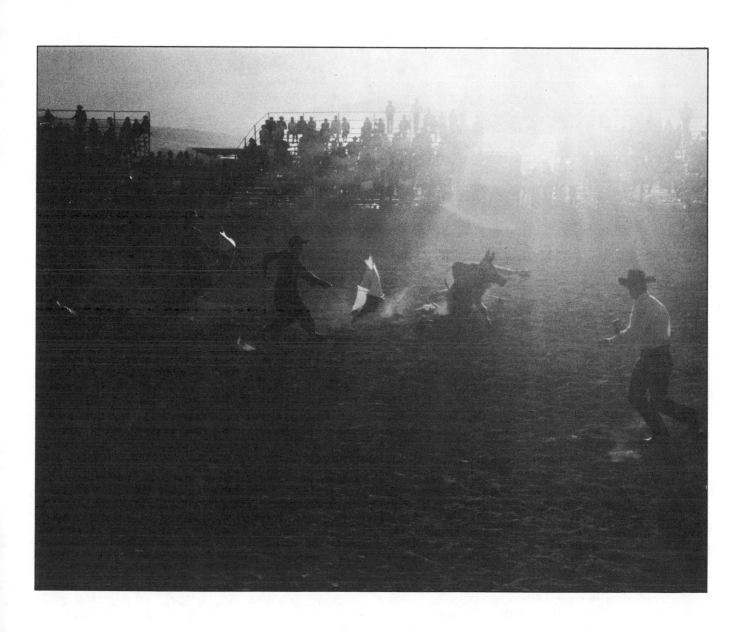

Environment and Background

These two photographs illustrate polarity in the importance of environmental details.

The street scene depends for effect on the inclusiveness of such details. It is an ample, loosely spaced, decentralized scene designed to be studied random bit by random bit. The brick streets, the signs, the dozen or so pedestrians, the linear perspective, the multiple lines of composition—all get attention and all contribute to the totality of the image. The scene could not effectively be reduced (cropped) without destroying much of its value in data and in the emotional response of the viewer.

Some photographers think/see in such looseness: they rely for visual effectiveness on the presence of considerable environmental or background details.

The second photograph, however, strips away any suggestion of environmental content. It provides an ultra-closeup image of expression and action, tightly composed to concentrate the viewer's attention on two faces. The imagery is tense, laden with impact and directness. It is concentrated, absolute. Without background, it still communicates effectively. It hits harder than the first image. It doesn't lend itself, however, to continued study. It draws attention fast and delivers the message in a stroke.

At three points in the photographic process, decisions must be made about including or excluding environmental details.

First, when the photographer composes his image in the viewfinder of the camera.

Second, in the darkroom when the photographer decides what exactly to put into the photographic print, at which point he might decide to change his stage-one (view-finder) decision.

Third, during the editing process when the photographic print, now being handled by an editor other than the photographer, might be marked for further cropping.

Cropping can be called for in these situations:

1. To exclude unnecessary environmental and background details.
2. To concentrate even more visual impact on selected details: for instance, cropping a head-and-shoulders portrait to just eyes, nose, and mouth.
3. To change the shape of the entire picture, such as creating an extreme lateral or vertical rectangle, or to change a rectangle to a square.
4. To eliminate highlights or other distracting content located on the rim of the print.
5. To eliminate, if possible, blemishes in the print.
6. Occasionally, to fit an image into an existing space in the page makeup.

Whether to include environmental details is not a decision made lightly. The details frequently support the meaning of the picture. For instance, the moods and emotions of a ghetto:

A closeup, cropped image of a young boy, even though disheveled, would provide an uncertain message.

But the same boy surrounded by rubble, rats, ruination—the background of a slum—photographically would be explicit in its communication.

On page 46 are two other images to study. One incorporates a moderate amount of environmental detail. The other is extraordinarily lean in its closed, cropped content.

Generally speaking, photojournalism must be a process of shooting closeup, of always searching out bold foreground information, and of cropping tight to increase the visual impact of that foreground. Background clutter is rigorously avoided. Background is included only when it clearly supports in some way that foreground content.

Isolate for impact.

Concentrate for attention to and retention of the message.

Background selectively and carefully when those details alter significantly the meaning of the visual image.

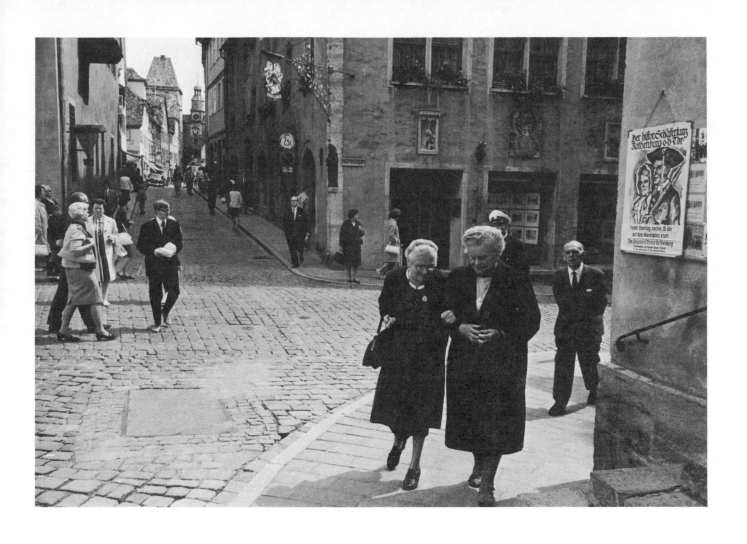

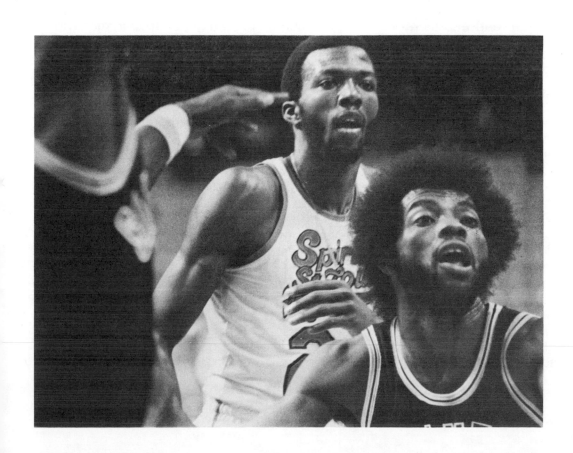

45

Environmental detail?—in or out?

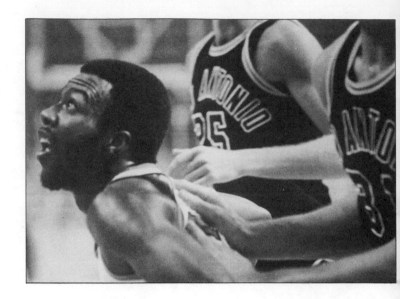

Closure—and
the Tightly Cropped Message

This photograph is visually incoherent; it is truncated (the wings and the feet) and therefore incomplete and somewhat unstable. The viewer, however, seeks to complete the configuration of the gull, extending the lines and shape of the bird, demanding psychologically a complete and therefore more comforting whole.

To psychologists such *Gestalt* is referred to as "closure," the insistence by the viewer that he complete the partial image in its details, in its structure, and in its meaning. Thus, the viewer actively participates in closing the image —as long as he is given enough symmetry, information, recognizable and familiar shape and form and line to continue the parts to make a meaningful whole. A communicator prefers this active participation of viewing over passive observation by the audience.

Closure is especially significant to photojournalism in which closeup, impactful points of view are preferred by the photographer, and tight cropping is demanded by the editor.

Costs demand a tight image. Before a photograph can be printed in newspaper, magazine, or book, it must be reproduced as a negative (offset printing) or as an etched, metallic plate (letterpress printing); both are expensive processes. The paper is expensive.

Space is a problem, too. For every publication, there exists many more times material than space to print it.

Therefore, in photojournalism, images are cropped and composed more tightly than in other areas of photography.

In this photograph, the wings of the gull could have been included in the original negative. A step or two back by the photographer would have enlarged the angle of viewing. Yet, the tips of the wings would supply no additional basic information, and might have led to additional black background ambiguously dominating attention.

Here, tight cropping is effective. The visual image multiplies in power.

The photo editor draws from psychology.

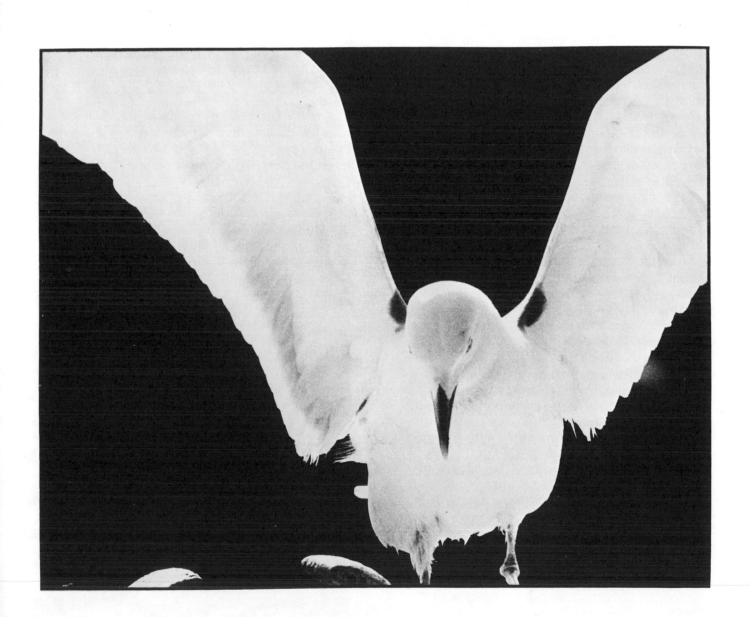

Synechdoche

This photograph illustrates a metaphorical device known in literature as "synechdoche," letting a part represent the whole for the purpose of greater intensity of meaning. Thus, when a teacher takes enrollment she "counts noses."

For this photographic synechdoche, a 2¼ × 2¼ negative was cropped severely in the darkroom as an act of postvisualization. The photographer had had quite enough images of runners at a track meet. Runners breaking the tape at the finish line. Runners stretching out their strides on the back lap of the 880-yard run. Runners charging at the start of the mile run. Runners collapsing, sprinting, grimacing.

All of these variations on a theme paraded before the photographer's eyes on the strips of developed film. He felt the need to tell in some new manner about the races, some way to show the desperate thrusting forward to win, the pumping and windmilling of arms and legs, the close-packed elbow-thumping crowds of runners, the ubiquitous white lines thrusting the runners on true courses to a finish line.

All of his images, the photographer felt, were clichés. They had been seen and felt before. And none on this particular day transmitted the intense universe that existed from starting blocks to finish line.

He turned to synechdoche to make the statement in its isolated intensity. The photographer in the darkroom kept returning to one negative. Runners full-length were bunched to the right of the image, open track stretched to the left. He put the negative into the enlarger and projected the image onto an easel. He reshaped the once-square image, adjusting the easel bars until he found the part of the whole that had been subconsciously attracting him.

There is unexplainable intensity to such metaphor. The mind snaps alert, and by the process the psychologists call closure the viewer supplies missing details. A little concentrated and recognizable information stimulates individual elaboration and interpretation, and the viewer becomes also part creator of the scene.

Sometimes, a few details provide greater impact than does comprehensive information.

The principal value of a telephoto lens lies in its ability to search out and record such highly selective details. A telephoto lens equals synechdoche. A 200mm lens, for instance, should be used not so much to close up distance between photographer and scene as for metaphorical statement. . . .

Cleated shoes thrumming down an asphalt track.

Knees propelled forward. Feet reaching to touch ground again.

Magnetic chalk lines drawing the racers forward.

A giddy sense of movement.

In the darkroom, in a picture within a picture, the photographer finally found what he had been sensing at the event earlier in the day.

Two other photographs aptly illustrate the power of isolated details. (1) On a snow-filled day referees keep the football dry between plays by burying it under a white towel. (2) Crossing a city street, an elderly woman keeps close companionship to protecting safety lanes.

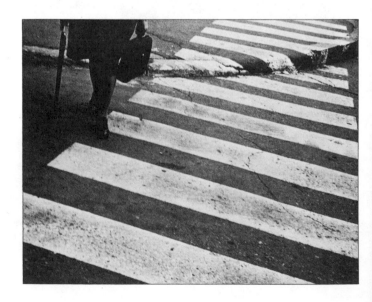

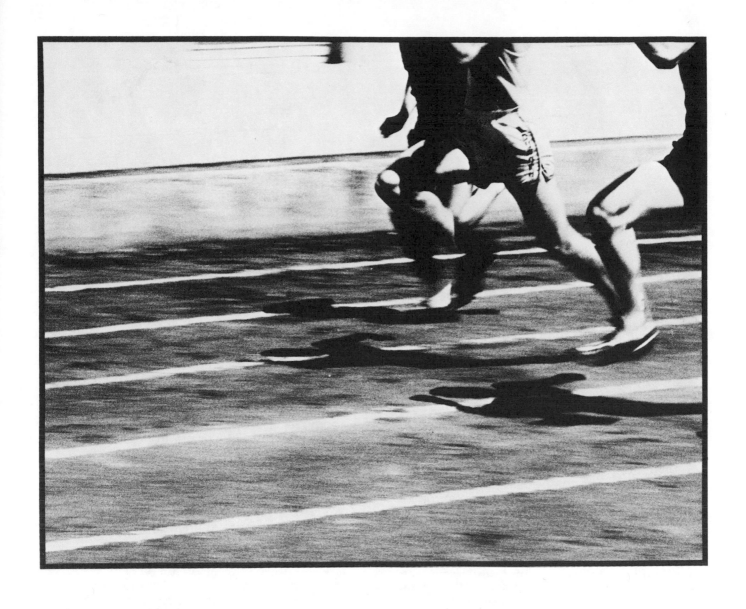

Candid Portraiture

A studio photographer places a person in a controlled environment—controlled lighting, controlled background, largely controlled pose—and then seeks on film some likeness of the subject. Much of the time the photographer wants to please his client with a flattering image; the more flattering, the greater the sales potential. Some of the time, the studio photographer hopes to implant on film more personality, through expression, gesture, lighting, and pose to reveal what lies behind the facade of the person.

Either way, the image is controlled, if not at times outright contrived.

The photojournalist looks at portraiture somewhat differently. His imagery tends to be more natural, spontaneous, true-to-life—in other words, photographically noncontrolled. *The candid portrait.*

When professional football player Dennis Morgan ran a punt 87 yards for a touchdown, there wasn't much action at a peak moment to photograph. His catching the football? Or running down the field? Or crossing the chalk stripe into the end zone? None of those image possibilities tells the story visually unless a sizable caption is appended.

Another option is always open to the news photographer. If he cannot portray with interest the action itself, he can show what the "performer" looks like.

Here he is, soon after the play, still releasing energy by pacing the sideline. In addition to his news value, the player is visually interesting, quite unlike what most fans think a football star looks like. The hair style and the headband and the beard contribute symbols of life-style. The bandaged hands add a signal of the violence of football. The player confronts the viewer directly. There is power in his facial tension. There is high energy being released in the sharp thrusting of elbows.

All of these characteristics a news photographer seeks in his "portraiture." He wants a newsworthy person photographed frontally and as closeup as possible during a natural activity occurring in a natural environment, and with all elements as noncontrolled as possible.

Nothing in this portrait is regulated by external controls. No one shouted to the subject: "Hold it!" No one repositioned a photolamp to add rimlight to the hair. No one constructed the environment nor positioned the supporting players in the photograph.

The only controls were internal to the photographer. He bore in close to the subject, he waited until the player confronted the camera, he calculated the proper technology for a sharply detailed face, and he finally chose the split second to record expression, gesture, and activity.

The photographer also understood that his subject was more than newsworthy, he was *photogenic.* In simple terms, the subject was interesting to look at.

Photogenic strength is not easy to characterize. Sometimes it is based on beauty, sometimes on salient and sharp features that are compositionally powerful, sometimes on visual representations of distinctive life-style, sometimes on personality showing through facial expression. Persons who are visually interesting, those photogenic, are sought by the photojournalist, who adds their images enthusiastically to his candid photo gallery.

The photojournalist learns quickly that he must look *at* people, he must be alert to their p.q. (photographic quotient), and once having determined the visual strengths he must be aggressive enough to seek to photograph them.

Most persons avoid such direct contact. They do not look at people. They feel the need to preserve personal distance. But the photojournalist knows that all of his visual images must be peopled, and that one sure way of augmenting the total effect of an image is to seek visual strength in those people.

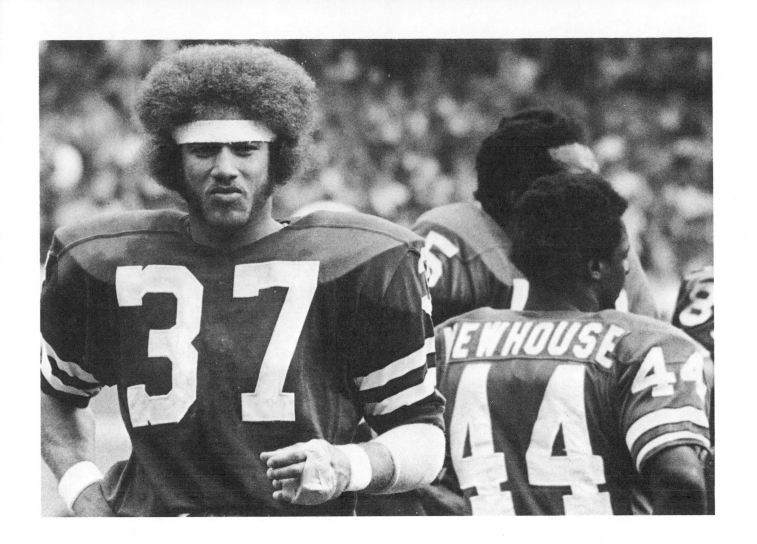

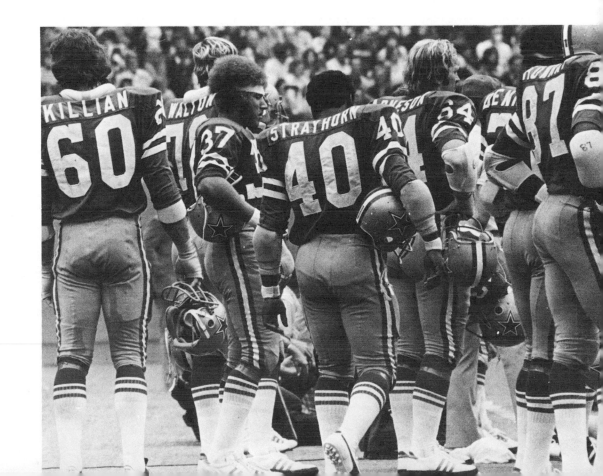

Aspects of Body Language

Words provide only part of a person's total force of communication. A repertoire ranging from natural personal appearance to planned gestures and expressions communicates with other persons constantly, in amazing magnitude, and with startling effectiveness.

More than a word-man, the photographer as a reporter is aware of those immeasurable nonverbal messages any one person can communicate at split-second speeds. A photographer must detect—better still, anticipate—a message-ridden expression or gesture and record it on film. He must be sensitive to human gracefulness on one hand to produce a romantic image. He must also be alert to the scabrous and the grotesque for its sensational content. He must respond to muscular expressiveness for the empathic response it invokes in the viewer. He recognizes bodily postures and angulations for the silent language they express.

The photojournalist builds his images from people, and therefore he becomes psychologist, intimate and confidant, artist, expert communicator—whatever is necessary to understand the total language of a human being, to anticipate that language and respond to it at microsecond speed in order to put it on film, and then to depend on it to gain attention and response from his eventual audience.

Thus, during a high-school wrestling meet, this photographer was attentive to the inherent gracefulness of some of the moves of the competitors. At certain moments all of this masonry of gracefulness came together to form peaks of expressiveness. A second before or after and the perfection of human form dissolved into awkwardness. So the photographer watched through the viewfinder for the perfect moment.

Photogeneity, too, is significant to visual imagery. A strong face—muscular, taut and lean, strongly ridged—is pleasant to contemplate.

Beauty is, too, in its arcs and balances and restrained features. Some faces are remarkable for their transmission of personality, some for their innate moods, whether bright or somber, some for their sensuality in eyes or in angulation of body. All this is part of *body language.*

The photographer understands about empathy, too, the tendency of the viewer under certain conditions to identify closely with what he sees. One kind of empathy involves direct neuromuscular response from the viewer. He sees in someone else familiar and emotional muscular activity and either responds with some minor movement of his own or, if there is no overt movement, *feels* some tension of those muscles.

This common gesture displayed by a young baseball player as he comes off the field—"How great it was," he says of the inning—can inspire in the viewer a feeling of shoulder-muscle activity, even inspire the slight upraising of arms.

The Greeks, for instance, sought such audience response to their sculpture by depicting, even in stone, realistic muscular tension and strong facial expressions. Centuries later, the Renaissance artist sought even greater fidelity to real people, real life. He incorporated into his work as much kinesthetics as he could, all designed to spur neuromuscular sensations in the audience.

In the 20th century the camera with its power of absolute replication of life became the most powerful instrument ever designed for invoking empathic response, that which one psychologist has called most vividly "inner mimicry."

Therefore, a photographer seeks in his imagery instances of motion and action—of motor activity—which in turn will inspire in the viewer a corresponding motor reaction, or a feeling of one.

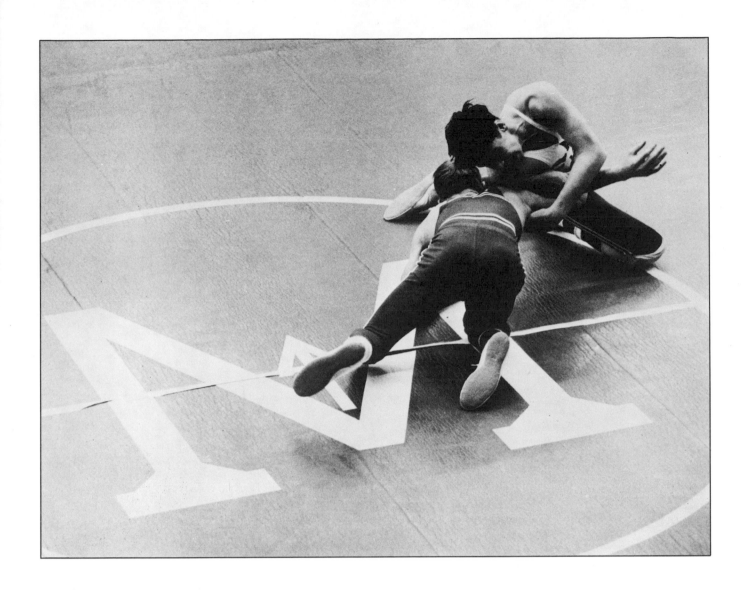

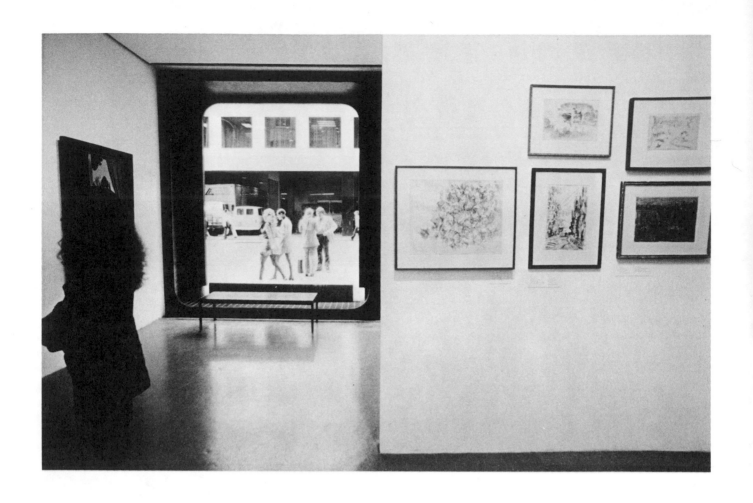

A Visit to the Museum of Modern Art

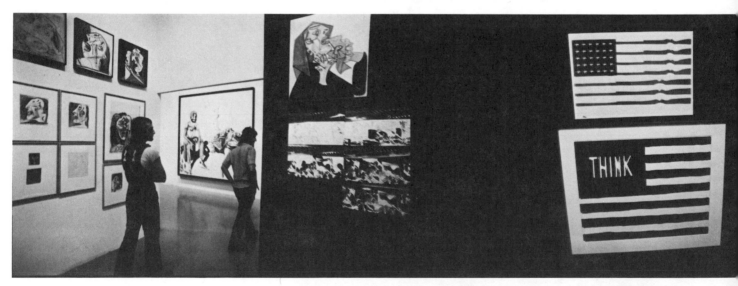

Two adjacent negative frames printed as one

The Essay in Photographs

The most serious mistake in photographing —to think in terms of a single image. The old one-assignment, one-image concept.

Several photographs about one theme on the other hand can weave an essay as assuredly as do words in the world of literature.

This photographer essayed about the Museum of Modern Art in New York City, one of the few art centers to allow patrons to take cameras into the galleries. The photographer was not concerned about the great pieces of art there; he wanted instead to photograph visitors to the museum in a style and attitude similar to the modern art on display for them.

And so a picture-window opening onto 53rd Street resembles a gigantic canvas, pop art perhaps, suspended from the wall of the museum. Two visitors backdropped by parts of two modern paintings (one by Robert Motherwell) form a third surrealist painting. One solitary man poses as the target of one resolute and direct line, the latter itself a painting. A double-frame image seems another piece of modern art (the double image produced by printing parts of two adjacent negative frames as one print image).

An essay like this starts with idea. It requires time and then more time for expansion. The idea cannot generally be transformed into imagery in a day of shooting. The final essay is spawned by careful selection and editing to maintain continuity and unity of the theme. For instance, all the images chosen for the museum essay must fit the thematic prerequisites of (1) visitors seen against art backdrops, and (2) the total scene resembling the modern art exhibited in the museum.

The idea grew out of early random shooting at the museum. At first, the photographer was interested in photographing the art. In his first contact proofs he found an occasional more interesting interrelationship between visitors and the art. He returned to the museum a half dozen times to explore that more specialized theme. He used wide-angle lens, telephoto lens, ultrafast film, double images—any photographic technology available to interrelate visitor and art.

Eventually, the photographer had a dozen images worth consideration. He then edited his work according to these guidelines:

1. No two images repeat in any way the same idea or information. No duplication even in parts of the pictures.

2. All images scrupulously fitted to the theme. No extraneous ventures allowed.

3. Every image strong technically and visually—an essay is only as strong as its weakest image.

4. The total number of photographs reduced and reduced again, to ensure the overall vitality of the essay from first to last. Too many images clutter the viewer's attention.

The essayist in the photographer should constantly be alert to ideas. A photographer should think in terms of several images working together, not just in terms of one image telling the story. Even when covering a spot-news event, like a football game, the photographer looks for and devotes some of his shooting time to a little essay—like concentrating on one player for a quarter of play.

Photographic essays are built on several kinds of themes, like these:

Time themes—a day in the life of . . .

Topical themes—cats, unusual sunglasses.

Place themes—Chicago, a small town, a visit to a toy factory.

Personal themes—the mayor, the star.

Creative themes—"parades are for patriotism," the museum interrelationships.

Sequential themes—how to do something first to last.

Event themes—story of a city council meeting, of a county agricultural fair.

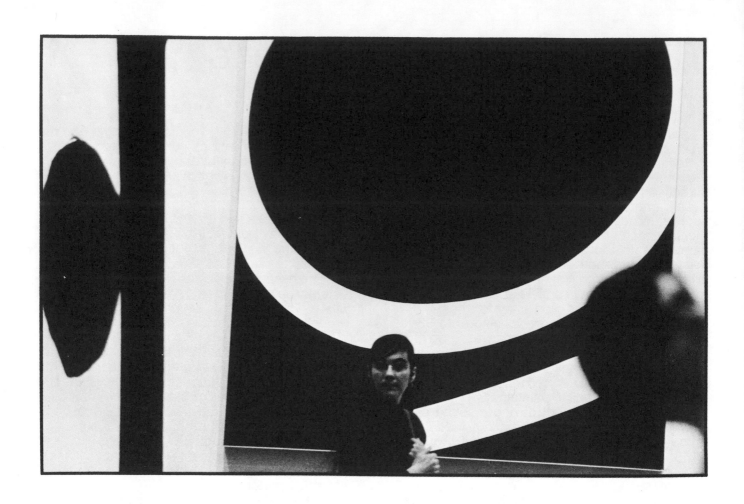

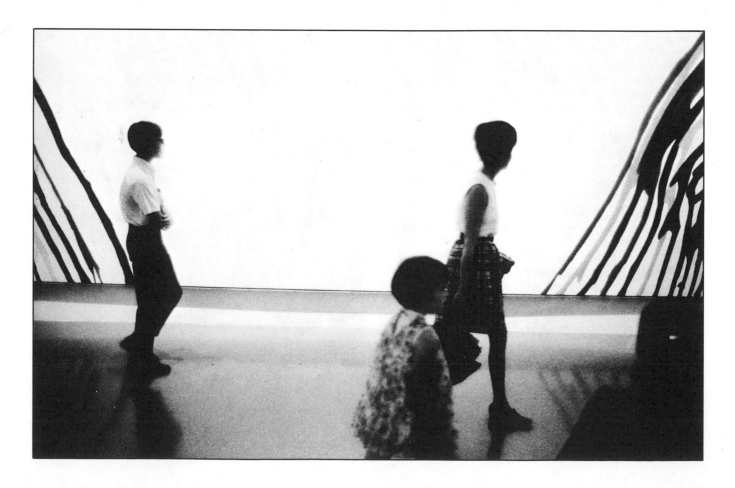

Page 56 bottom: Synthetic polymer on canvas by Morris Louis.

Right: Painted aluminum by Ronald Bladen. Below: Composite sculpture by Louise Nevelson.

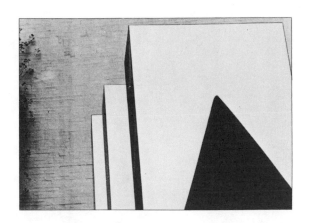

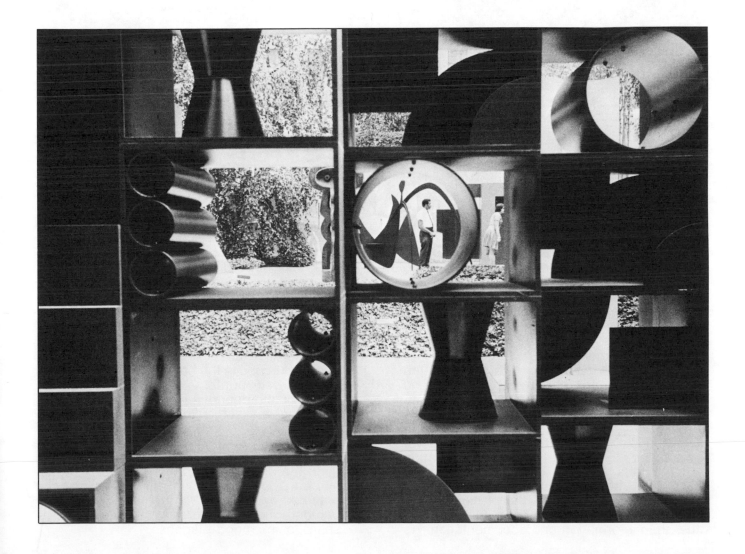

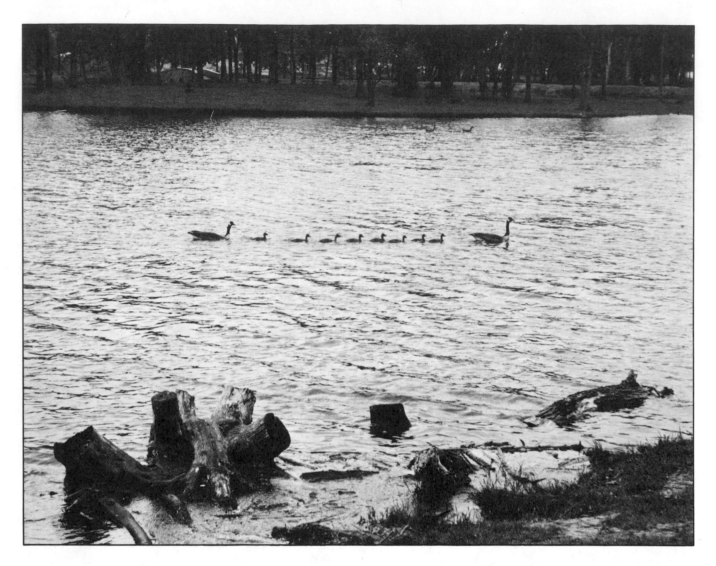

An Eye for the Ironic

Some call it a mood shot.

Some refer to a keen eye for irony.

Others prefer using the term "feature."

Whatever the terminology, in the photo at the top of the page there is something of singular impact. The precise line of goslings is enclosed by two parents who resemble parenthesis marks. A series of similar lateral lines, top and bottom, stress even more the ineluctable logic of that arrangement of Canada geese.

Second-level associations are stimulated about parental care, about keeping the young in line, about the orderliness of nature.

In the juxtaposition of the various elements in this photograph lies a mood, lean and concentrated like an arrow that strikes the viewer instantaneously and with powerful penetration of the senses.

Mood . . . irony . . . feature . . . this kind of photograph demands that the photojournalist communicate with an audience with something other than information and documentation. He searches the resources of his assignments for these peculiar juxtapositions. He looks into his viewfinder with an eye conditioned to the ironic.

Like the scene of a single wide-finned car on a slow Sunday disrupting the consistency of design of a parking ramp.

Like the ubiquitous "1-hr. parking" sign with a knotted cluster beside it—parked boats, a totally unexpected conclusion to the visual story.

Like one final resounding "Stop" sign amid a proliferation of "Go" signals.

Like clutched in the hand of a dignified public statue a beer bottle.

And on the door of a professional forwarding company, a plain ordinary everyday sign announcing that the company has forwarded itself elsewhere.

All these, in a sense, visual gags depend upon the unexpected interrelationships of elements in the picture, visual conflicts which once detected and isolated and emphasized by the photographer's work prod from the audience a sharp, quick mood response.

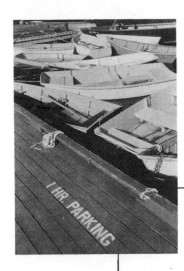

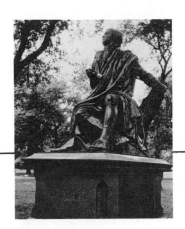

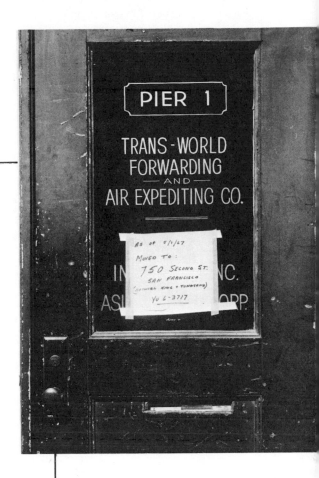

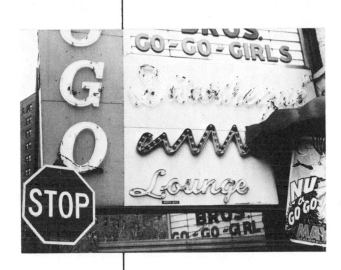

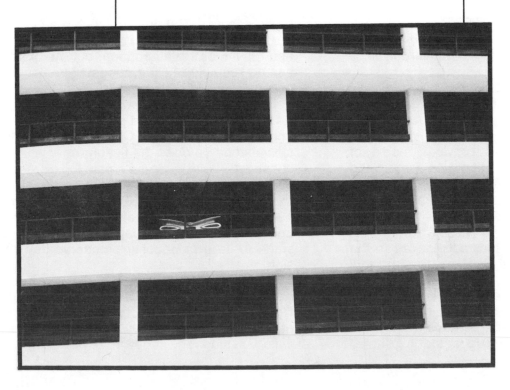

Narrative Art

Narrative art is as old as the ballad and minstrels, the Dead Sea Scrolls, and hieroglyphics and ideograms.

During the 20th century four powerful new media have taken control of the narrative—photography, then film and radio, and finally television. Each instrument tells a story more powerfully perhaps than previous media of communication, and certainly to larger and larger simultaneous audiences.

The photojournalist uses his camera in part as an instrument of narrative. In this photograph the story is there visually to be put together. A basketball player, knocked to the floor, plaintively asks the referee why no foul has been called. He is aided in protest by a fellow player. Another teammate in resignation helps the plaintiff to his feet. An opponent (in white uniform, of course), perhaps the alleged offender, looks away in disgust that he should be so accused. Caption material in a newspaper would provide names and places and times and results of the altercation, but the plot line can be seen clearly and needs no verbal introduction.

The photograph as narrative art.

Storytellers in oral and print literature are as ancient as Beowulf and Chaucer. A playwright tells a story. So does the fiction writer when he constructs plot. Some paintings recount events. Balladeers carried tales and history from place to place. Drama in the 1930's and 1940's provided the peaks of radio performance. Television has adapted drama and the stage to its own peculiar electronic transmission.

The photographer, too, is a narrator. Among his many purposes for embedding image on film is narrative—in a photograph or by a series of photographs to convey plot line, characterization, setting, and mood to a viewer.

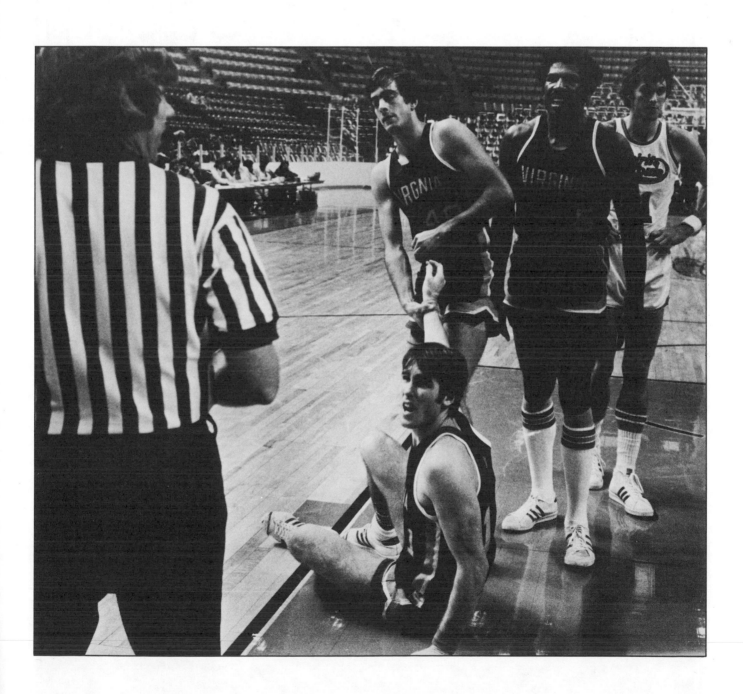

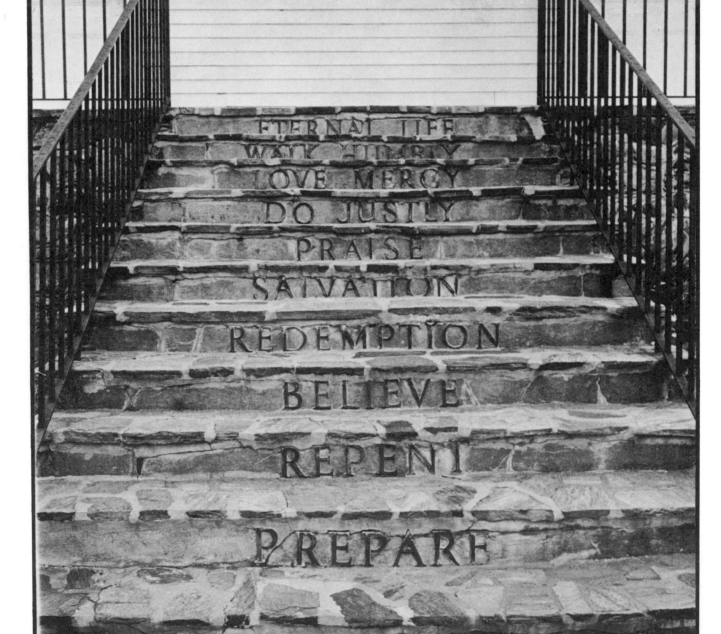

Composition and Other Aesthetic Content

The deist may see the universe as harmonious and perfected, running smoothly and exactly. The photographer, however, through the camera eyepiece perceives the universe as largely discordant and random, challenging him to put it into some kind of order and to give it some degree of emphasis.

If a photographer's only task were to imprint on film the universe in its constant flux and disorder and irrelevancy, then he would better hold the camera at arm's length, point it aimlessly, close his eyes, and squeeze the shutter release at the most uncalculated intervals.

Once he applies his attention to the viewfinder, he selects special moments for exposure, and generally those moments contain some kind of order, some kind of center of attention.

It is not so much "creative seeing" for the photographer as it is an innate motivation to do something "selective."

Any image to some extent is determined; it rarely is accidental. The photographer cannot help but assess and calculate, opt and change his mind, running split-second images through his two computer systems—one logical and one psychological—evaluating and finally selecting an image to record on film.

Success overall depends on the ability to perceive interesting order and meaningful emphasis. That makes every photographer to some degree an artist.

To say that a news photographer concerns himself solely with composition, textures, contrived tonal effects, and other art effects would be giving him unrealistic frills and airs.

To say that he has little or no concern about photographic aesthetics would be demeaning his final product.

He must have some concern with what are called the artistic aspects of photography, although because of the speed at which he must work he cannot meticulously calculate every line, shape, and proportion.

News content—that generally describes a photojournalist's first concern. He must have a newsworthy moment on film, or the height of action, or a candid image of some newsworthy person, or a mood-filled image worthy of delight, or a record image of some scene of news, or a significant environment. Those image necessities dominate his attention, particularly when he has eye applied to viewfinder. He also works at microsecond speed, without much time for meditation and contemplation, because most of his images are that fleeting.

Despite those preoccupations and time pressures, the photojournalist does try to incorporate into his images as much aesthetic as possible, although his decisions may be simplistic and the product of a minor split-second adjustment here and there. There is no such thing as adjusting and readjusting camera position or exposure controls to improve the artistic aspect of the photograph when a building is caving in on firemen, or a football halfback is racing for the end zone.

Basically, a photojournalist's catalog of composition would consist of readily visible, quickly assimilable elements such as:

Patterns.
Perspective.
Balance and, of much greater value, imbalance (or contrast).
Proportion and scale.
Lines and arcs (especially when cropping a negative in the enlarger).
Overall, the interior design of a photograph.

As for other elements of aesthetics, the photojournalist can be concerned to some extent with print tones (high key, low key, high contrast, soft contrast) and with textures.

For the next several pages, photographs will illustrate each of these basic points of quick aesthetics. Some commentary will accompany each photograph.

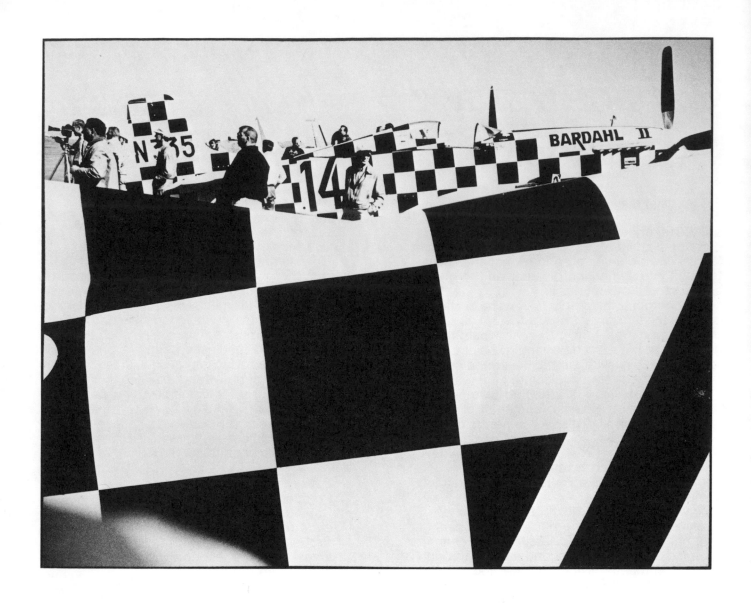

Patterns

The simplest combination of order and emphasis lies in patterns, which consist of repeated shapes, lines, colors, and tones. In that regularity is found form, like this:

/ / / / / / / / /

However, too much regularity tends to produce boredom; therefore, some irregularities should be incorporated into the pattern, like this:

/ / /\/ / / / /

This photographer at the national air races was struck by patterns of two checkerboard-painted planes parked side by side on the apron of the airfield. Throughout the day he had been using a telephoto lens and a fast shutter speed to photograph planes racing and banking around pylons marking the course. He also had been seeking candid, informal portraits of the outstanding pilots, trying to interrelate them with their machines.

Then, late in the day, he patrolled all the other environments of the air races, looking for different visual effects. (Some time for experimentation a photographer should always devote to any event.)

These patterns loomed in his viewfinder, from the two yellow-and-black planes. Two decisions were made, one technical and one compositional. First, the aperture of the 35mm lens was closed down enough to get both planes in focus (ample depth of field). Second, the closer plane with its great squares was allotted two thirds of the image. The background plane was given one third. That led to asymmetry rather than balance in the composition.

sponds automatically to any sense of repetition in his imagery.

In the two street images, notice how some element of repetition has established an order for each picture.

In one case two identical window frames, a number of lateral lines, and an overall texture set up patterns; but the patterns are broken unexpectedly by a semaphore. Also, a small "No Parking" sign repeats the shape of the windows, but as a variation rather than an imitation.

Several repetitions establish order in the other street photograph, but two persons provide irregularity; also, the three window signs are asymmetrical and break the patterns.

Arranging content equally on both sides of an axis from top to bottom or from left to right of a photograph provides a sense of perfect balance. The effect is pleasing, simple to understand, calm in its demeanor, but obviously contrived and lacking a sense of movement.

The photograph, on page 62, of a church is perfectly balanced. If split down the middle the photograph would fall away evenly weighted to the left and to the right.

It also incorporated some irregularities among the patterns. The decisions were made quickly.

Man responds to rhythms and syncopations. They thrum into his perceptions. Man as an observer also tries to create order out of chaos. Pattern is the frequent result.

For both those reasons, a photographer re-

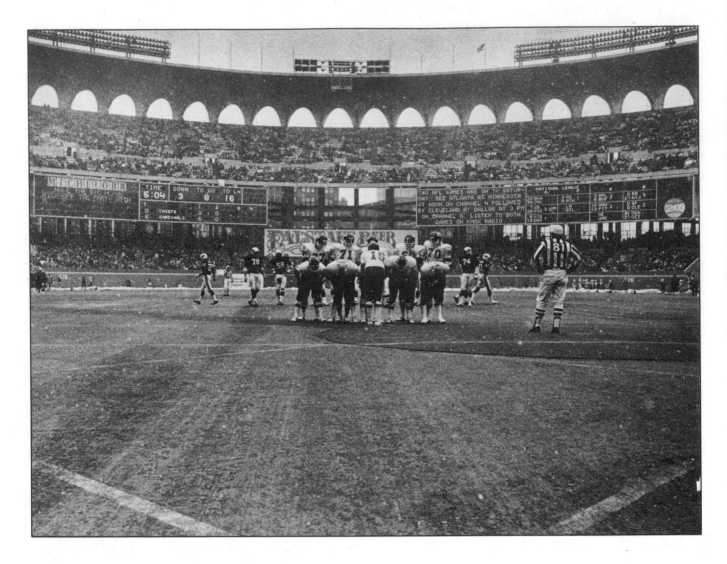

Balance

The football scene above is almost as precisely balanced, lines matching left and right, movement matching, even weights (like the scoreboards in the background) offsetting one another. However, the photograph includes one imbalance, the referee alone to the righthand side.

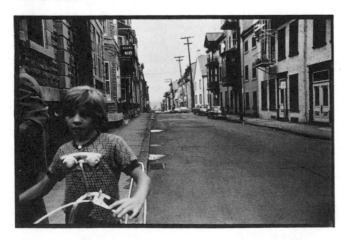

Imbalance

A dynamic, unexpected, and less contrived effect is brought about by imbalance. In the photograph of sailboats (next page) notice that the righthand side little resembles the lefthand side. There is a greater sense of movement, of reality, and of unexpected content from one section of the photograph to any other. Yet, to save the content organization from chaos, there is just enough repetition (vertical lines of masts, similar shapes of sails, human figures) and weighting of volumes (two big sails to the right are counterbalanced by one sail to the left but located at the very edge of the image—on a teeterboard the heavier person sits closer to the fulcrum than the lighter person, who sits out on the edge).

Imbalance is exaggerated here

Proportion and Scale

Scale: The overwhelming size of the sail is obvious to the viewer, even if he never has seen a sailboat; he compares the sail to the size of familiar objects to him, persons.

Proportion: In organizing the space of the four-sided picture, the photographer creates further dynamics by giving a disproportionate 80 percent to the sail and only 20 percent to the rest of the image.

Perspective

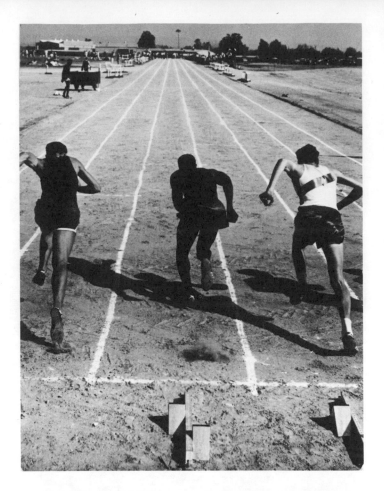

It has been reported that primitive man when shown a photograph does not perceive perspective in it; that is, he doesn't perceive foreground, middle-distance, and far objects in the photograph as forming any kind of visual impression.

The idea of a visual image containing a sense of depth, even though physically it is created on two-dimensional substance (like paper), emerged among artists during the Renaissance. They became fascinated with creating that third-dimensional illusion through perspective lines (see the track photograph at right), through overlapping tones (darker tones foreground, lighter in background), through dominant colors (red foreground, green middle ground) and recessive colors (blue), and through dissimilarity in sizes of similar objects (people in background smaller than people in foreground).

All of this investigation into perspective has been incorporated fully into photography. These three things are needed: (1) a normal- to wide-angle lens (no telephoto); (2) stopped-down aperture (f.8 to f.64) for depth of field from closeup to the camera to the horizon; and (3) the presence in the scene to be photographed of perspective lines, tones, colors, or scale.

In the photograph of the cowboy at rest at the corral, notice the combination of foreground and background objects, the depth of focus, the lines, and the scale that provide a keen sense of depth dimension.

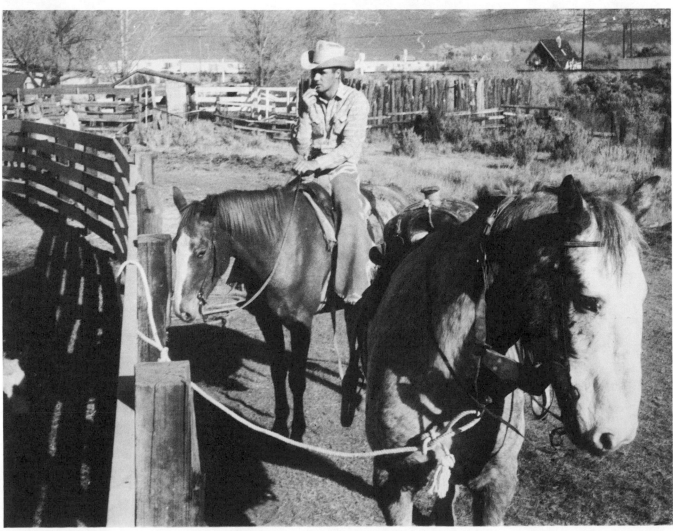

Lines of Force

Four thrust lines contribute to the bottom photograph a powerful left-to-right locomotion. The outstretched arm forms one line of force, the finger another. The other two lines are provided by the top and bottom edges of the photograph. All this lateral movement is augmented by shallow, lateral cropping of the picture. No negative exists naturally in this shape. Lines of force—"directive lines"—can be lateral like these, or vertical or diagonal. In all cases, such lines dominate composition.

Gentler, softer, more sophisticated, more beautiful, more graceful—the curved lines. A meandering line is directional, but it is not as imperious as a line of force. It might be said that a straight line exudes realism; an arc, romanticism. In this photograph arcs are plentiful, in the chalked lanes, in the curbing, and in the grouping of the runners. However, to bring those arcs back to some degree of hard reality—after all, this is a scene of competition—the arcs are contrasted in the foreground against the straight lines of a steeplechase barrier.

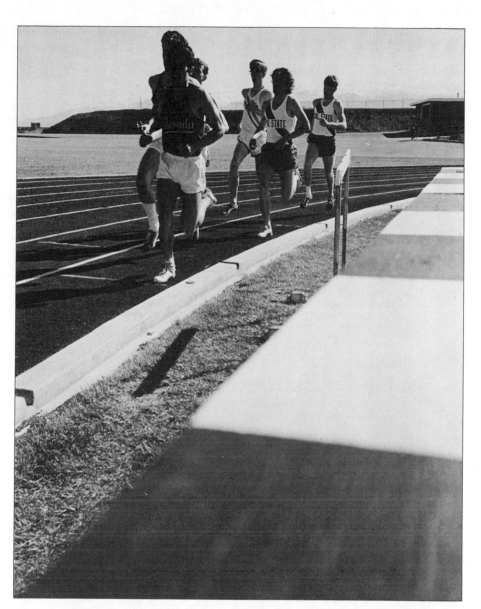

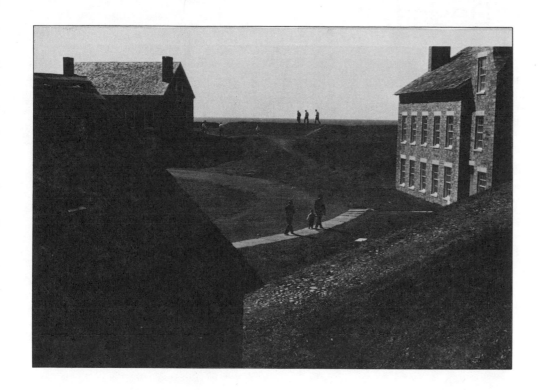

Interior
Design

Some persons refer to the "organized space" of a visual image. Some use the term "interior design." Others refer to "architectonics." In every image the photographer instinctively tries to combine lines of force, perspective, balances and contrasts, weights and volumes, patterns, proportion and scale into a well-designed picture.

In the MG-church photograph (opposite page), all these elements work together effectively. Patterns are there, in the sideboarding of the church, in the grille of the MG, in the reflections from the hood of the car. There is a sense of balance in the centering of the car, but of imbalance in the leftward shift of the church. Perspective is abetted by the narrow section of background revealed to the upper right. There are strong directional lines of force, offset by gentle arcs of the car. More than half of the visual space top to bottom goes to church, less than half to car.

In the photograph (top right) of visitors at a fort at Oswego, New York, again the multiple compositional elements fall together in an organized, yet not deadly repetitious, package.

In the photograph at bottom left, three distinct compositional elements are organized by a single triangular interrelationship. It is a loosely composed photograph, with ample amounts of neutral space serving as a foil to the two groupings of persons and the one set of hurdles. In the interior design, first attention goes to the hurdles because of their light tones as contrasted to the overall density of the rest of the picture.

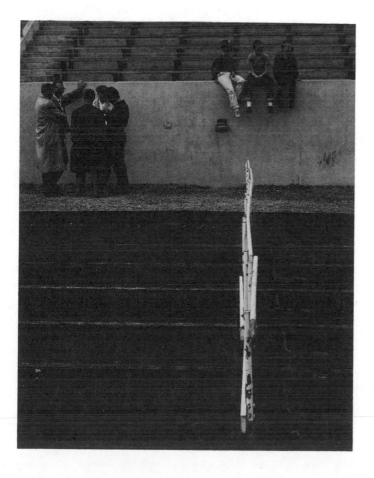

Modular Design

For an ultrasystematic and modern method of arranging interior space, a photograph is subdivided into modules. Each principal item of content then fits into a rectangular or square section consisting of so many modules.

The Civil Defense photograph, for instance, is arranged by blocks. The four elements of composition fall into those modular arrangements.

In less precise distribution of content, the photograph of two houses is based on modular arrangement, with the white house and fence occupying three fourths of the total space and the black house filling the other fourth. This composition was not systematically measured; it was roughly gauged in the viewfinder. The photographer first visualized the picture space as being blocked and then fitted squares and rectangular-shaped content asymmetrically into those modules.

Tension

Composition can involve a tug-of-war among forces within a photograph; a design is uneasy to look at if it sets up tension within the viewer. However, tension can effectively catch attention, then hold attention.

These two photographs represent two kinds of tension. In one, the two principal elements are positioned at opposite sides of the picture, threatening to rend the center of the image. A thin unsteady arc tries to hold together post and prow of boat.

In the other, countermovements provide tension. Three persons stride with great determination off the right side of the image; one person goes left.

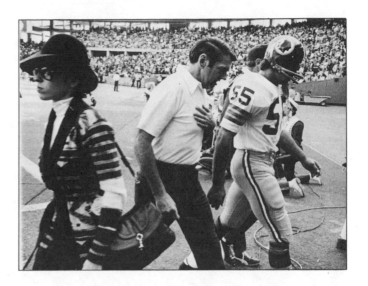

Above—low key
Right—high key

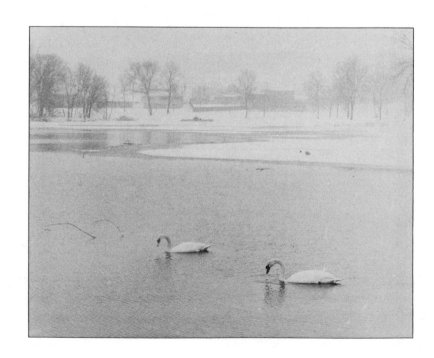

Tonal Effects

A black-and-white photograph consists of a number of grays, blacks and near-blacks, whites and near-whites. By varying these combinations of *tones,* a photographer technologically can create a number of effects, emotional and informational both. The tones can be clustered from a soft gray to the white end of the tonal scale, contributing a feeling of luminescence, of vagueness, of airiness, as in the photograph of two swans in a snowstorm.

In contrast to that tonal selection, the tones can be clustered from heavy gray to black, the dark end of the tonal scale, producing a somber, moody, mysterious aura, as in the photograph of professional football players bundled against the snowfall.

The first effect, light-toned, is called "high key"; the dark-toned, "low key."

Another variation—the tones can be contrasted, some from the black end, some from the white end, but without much gray in the middle. This "high-contrast" effect is startling. It jars the attention. It is decidedly unrealistic, as in the candid portrait of the young woman. This contrasting effect is called "a short range of tones."

Also, the tonal range can be subtle, including a delicate interlacing of a great many shades of gray, a touch of black, and a touch of white, as in the photograph of a boat cruising past the Milwaukee skyline. This assortment is referred to as "a long range of tones."

In fact, several tonal variations can be printed from one black-and-white negative merely by changing the contrast of paper, or by changing the dilution of the developer, or by changing the exposure time in the enlarger. These two different tonal effects of a boat passing under one of Chicago's bridges result from two different enlarger exposure times, one about twice the other.

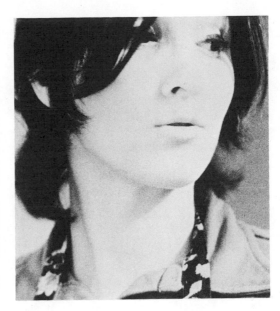

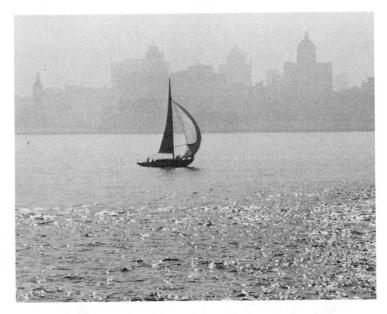

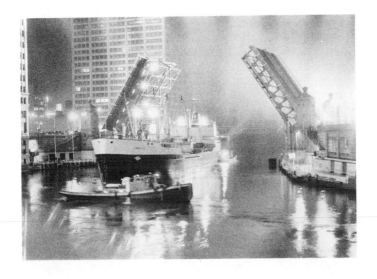

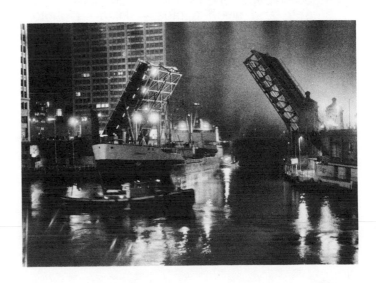

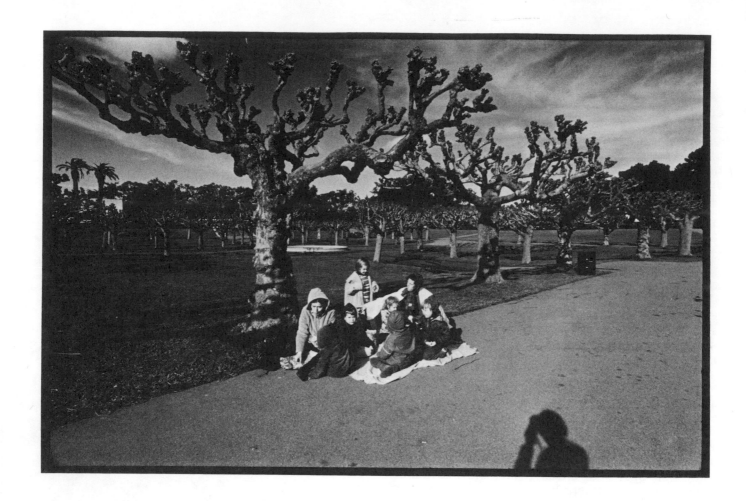

The Tactile Image

Despite the fact that a photographic print is made on paper of one uniform surface—usually smooth and given a glossy finish—a photographic image can transmit the impression of several different textures. The picture of a group of persons under the trees in a San Francisco park communicates feelings of several rough textures, stimulating the fingertips of the viewer as much as the eye. There is obvious texture in the grass, another texture in the asphalt walk, another in the knotty, craggy trees, and still another in the wispy-clouded sky. Some of these textural effects are inherent in the original scene. Others are augmented by a red filter which gives the sky a soft texture and the overall photograph a heavy tonal quality, and by the use of Kodak 2475 film which automatically produces an exceptionally grain-filled print.

Such visual imagery is tactile in its sensory appeal, not optical only. Textures inspire tactile responses, feelings of contact with the skin. Such imagery appeals psychologically and possibly shortcuts the brain to communicate more directly with the central nervous system, the reason why aesthetic photographers rely strongly on textural content in their photographs.

In the set of photographs on the next page, several ingredients inspire tactile responses—gravel (and a smooth black cat), a rough stucco wall behind aluminum-slick garbage cans, raindrops on automobile chrome, and thistle flowers in a bearding grain field.

KODAK TRI X PAN FILM

Graphic Effects

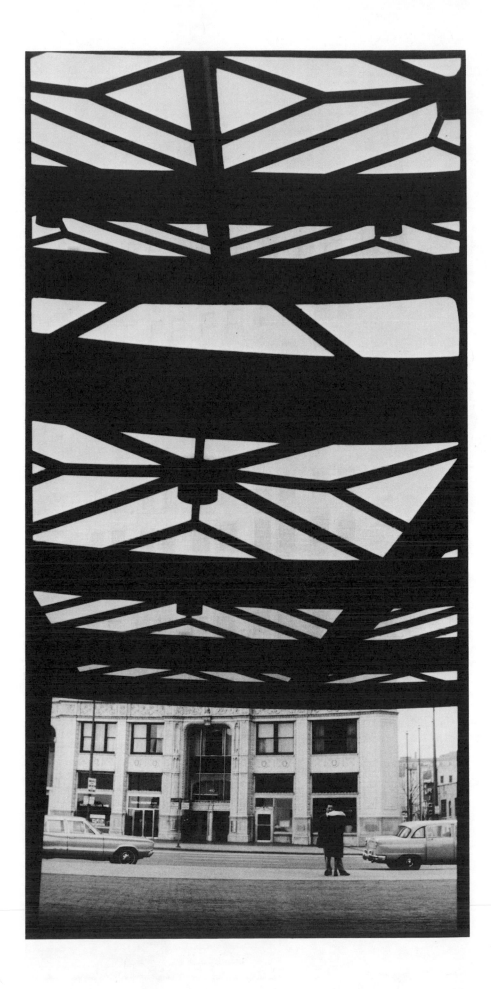

In recent years the photojournalist has become an illustrator as well as a recorder of news. That has led him into exploration of unusual photographic techniques, into increasing interest in images strong in symbolism and emotion. He studies every facet of new technology, for instance, that might produce an extraordinary visual image that would in turn draw fast attention from the audience.

These possibilities of *graphic effects* have added new dimensions to photography, and photojournalism lessens in its objective function and enlarges as subjective expression.

On these pages are reproduced photographs that to some degree are the product of special techniques and effects. Here are descriptions of the simple technology of the images:

Opposite page—Multiple printing. In the enlarger, parts of two consecutive 35mm negative frames, held in an oversized negative carrier, are exposed on one sheet of paper. Even the sprocket edges of the film are included in the final print.

This page—The same double-frame technique, this time to exaggerate the overhead structure of an elevated line in downtown Chicago.

Next page—(Top photo) Bleaching. The cluster of

cats purposely was printed very dark, and then a bleach solution (Farmer's reducer) was used to lighten the one cat looking up at the photographer.

(Bottom photo) A combination of effects. From a naturally black-white scene, a dark print is made on high-contrast paper, then the entire print is soaked in Farmer's reducer.

Page 81—Multiple printing times. On a sheet of high-contrast (No. 6) photographic paper, the top half is given just enough exposure to produce a high-key, evanescent set of details. That part of the print is covered and the bottom half then is given an additional exposure to create a low-key, somber effect. Ultracontrast in tones is the result.

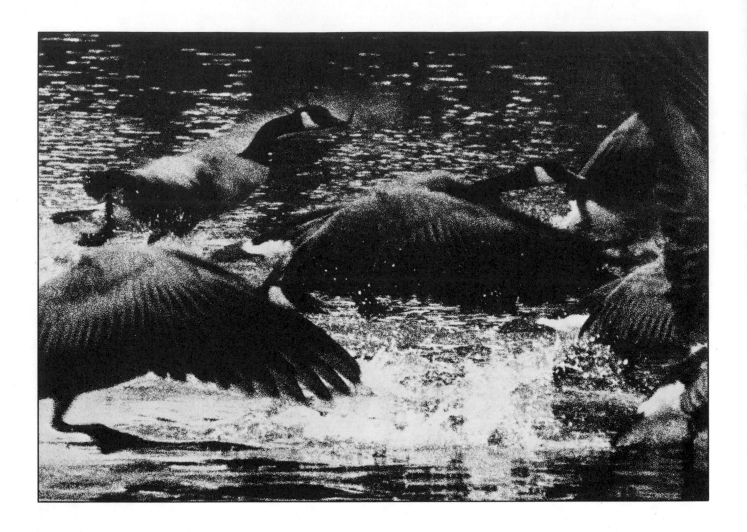

(Top photo) Screening. A grain-texture screen is sandwiched with a normal negative in the negative carrier of an enlarger. Exposure is made on high-contrast print paper, creating a special textural effect that heightens the feeling of speed and emotion in the takeoff of Canada geese.

(Bottom photo) Ultracontrast. A dense, contrasty negative is printed on No. 6 paper to create a borderless, two-tone, free-form image of ducks on water.

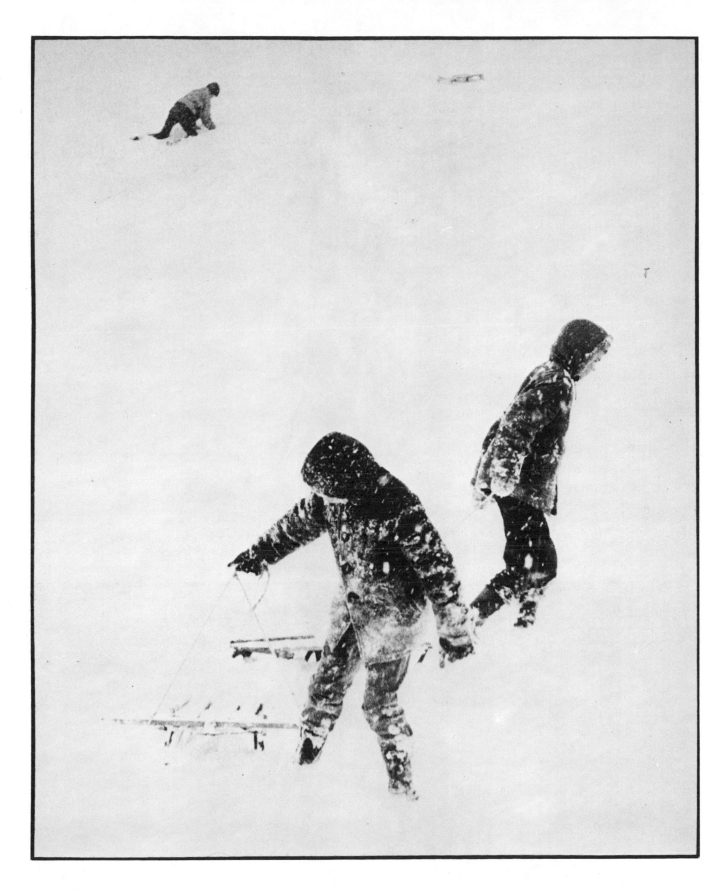

Double printing. Two negatives are printed separately on one sheet of paper. First, the negative of two sledders is focused on the bottom two thirds of the paper and exposed (only a high-contrast negative will work in order to leave a white background). Then a second negative is focused on the top third, boy and sled, to create artificially a sense of third dimension through scale perspective.

Page 84—Special film characteristics. A coarse-grained film like Kodak 2475 gives a photograph an overall soft-grain texture which resembles that of a fine pencil sketch. Notice the graphite texture on the doors and in the window frames. In the 2475 scene of two churches at Virginia City, Nevada, snow looks more like sand.

This page—Special film characteristics. Ultra fine-grained film reproduces as a moody, low-key photograph with good tonal separation in the dark areas. Film is High-Contrast Copy Film developed in H&W Control for continuous tones.

The Abstract Image

When visual elements are reduced to essence of shape and form, of line, of tones, of color, of texture, and of composition, then a photograph ceases to communicate information and objective reality. It becomes instead a largely aesthetic experience, and an intensive one because the usual visual message has been reduced to a distillate. Form and shape are accepted as just that—form and shape—no longer representing a definable object. Color no longer helps convey the reality of a scene; color instead becomes an intensified experience in—color.

This simplification of the elements of a visual image is referred to as *abstract* imagery, and it has little significance in news photography, which is highly functional, pragmatic, and utilitarian. Such visual simplification tends to confound the audience rather than inform it clearly or entertain it. Photojournalism is more concerned with objective function than subjective expression.

The abstract image is important, however, to illustrative photography. It is the province of the art photographer.

Familiarity and identification are essential to most photographic images, certainly to attempts to communicate with a mass audience. Even when an abstract image is presented to an audience, most persons try to identify it objectively. The viewer tends to bend what he sees and hears to fit his previous experience and his cultural conditioning. One critic has referred to this constant insistence on familiarity as "a looks-like-feels-like-and-reminds-me-of" response.

Photographic abstraction has gained popularity during the 20th century, with more and more exhibit photographers purposefully distorting and rearranging the visual elements of their photographs. Advances in technology have encouraged photographic expressionism. So has the formal education of photographers in art, history, and psychology.

How does a photographer deploy a camera and his insights to reproduce something other than what is in front of him? By ingenious and complicated darkroom experimentation. By using microscopic and macroscopic lenses. By techniques of blur and camera movement. By multiple printing and exposure. By extracting from everyday scenes isolated shapes and textures and colors and lines (like Aaron Sisskind's photographic images of peeling paint).

By daring to reshape the image at every conceivable step. For instance, a completed photographic print could be arithmetically divided (1–2–3–4–5–6) like illustration A on page 88, then cut into numbered strips and reassembled by an arbitrary numerical sequence (1–3–5–2–4–6) like illustration B on page 88.

Not all photographs on the next few pages are scrupulously abstract; some are to degrees definable and familiar. Yet, in each image the photographer has reduced visual elements to essences, by that essence of content attempting to communicate feeling rather than data, appreciation rather than information, and personal statement rather than objective.

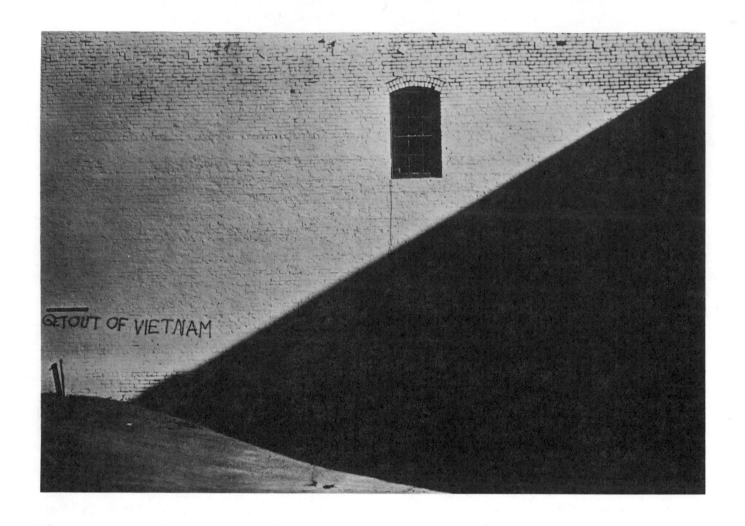

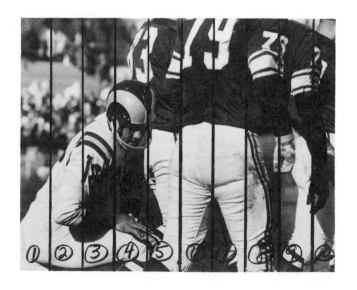

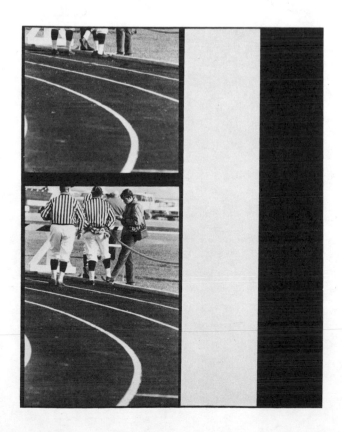

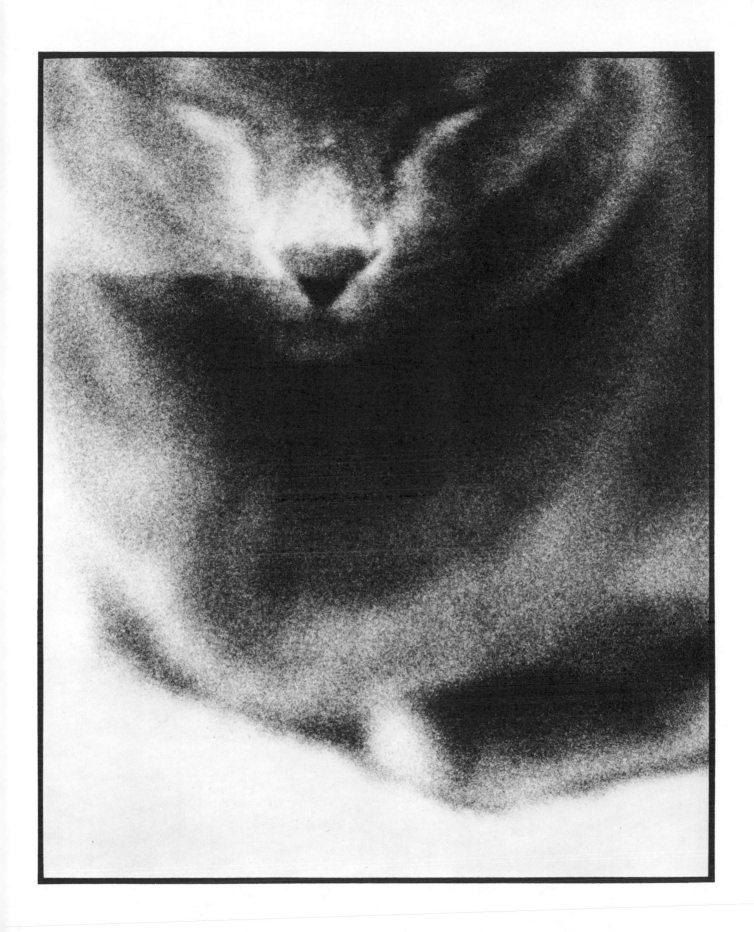

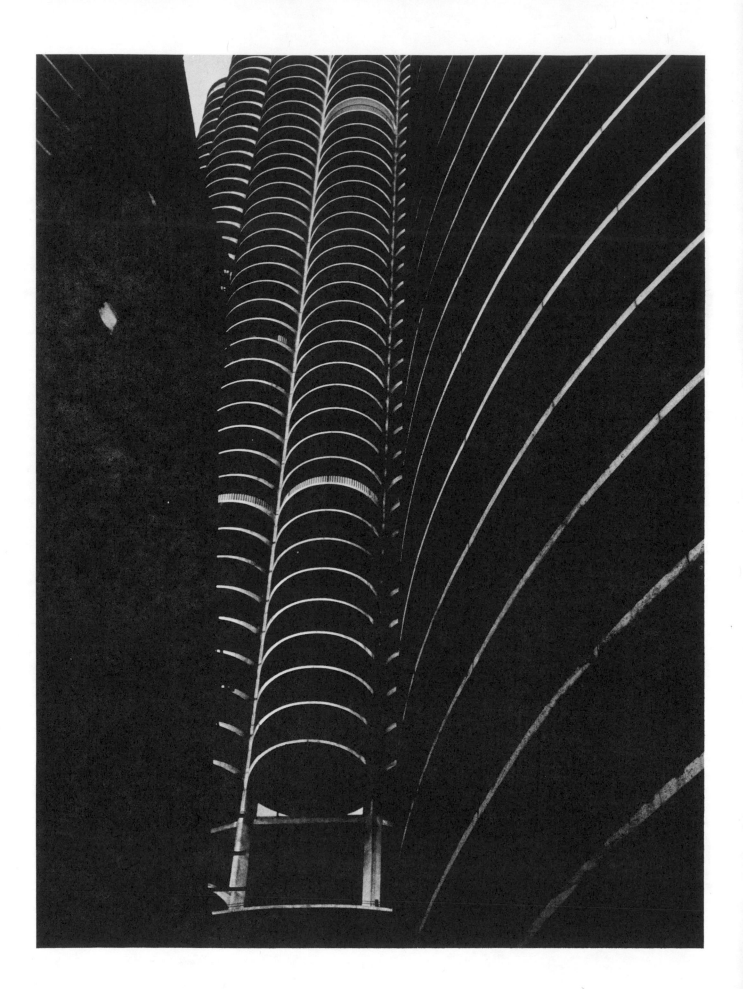

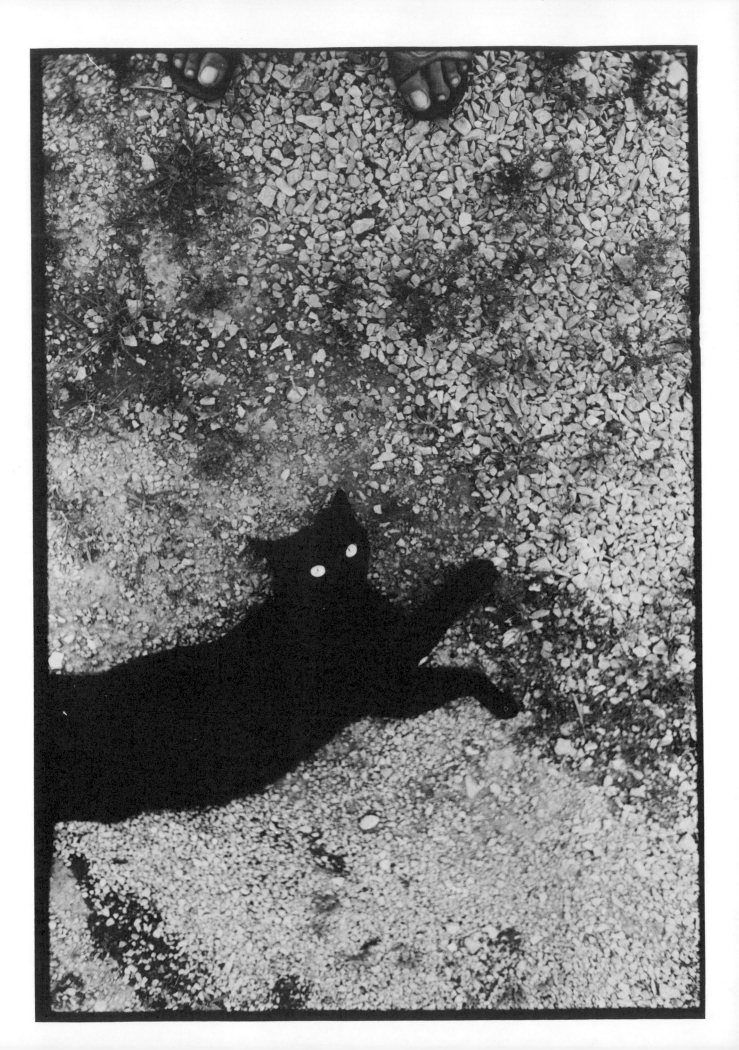